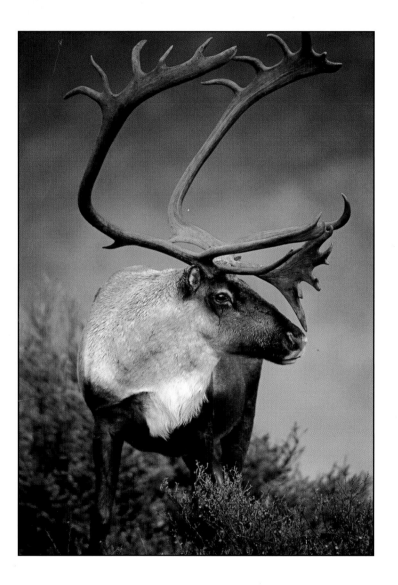

SEASONS OF
ALASKA

Alaskas Jahreszeiten　　アラスカの季節

Seasons of Alaska

Edited by Edward Bovy and Alissa Crandall
Text by Kim Heacox
Translations by MKI International
Cover photo: Mt. McKinley and Alaska Range
 from Lake Kashwitna. Photo by Allen Prier.
Title page: Caribou, Denali National Park.
 Photo by Craig Brandt.

ISBN 0-936425-76-8 hardcover
ISBN 0-936425-77-6 softcover

Published by:
 Greatland Graphics
 P O Box 100333
 Anchorage, Alaska 99510 USA
 email: info@alaskacalendars.com
 web: www.alaskacalendars.com

Printed in Hong Kong
10 9 8 7 6 5 4 3 2 1

Many of the photos contained in this book are
available for individual purchase or editorial use.
Contact us with your specific needs and we will
forward your request to the appropriate photog-
raphers.

Alaska Stock can be reached at:
 www.alaskastock.com
Accent Alaska can be reached at:
 www.accentalaska.com.
Many photographers have their own web pages
and can be reached via the Alaska Society of
Outdoor and Nature Photographers at:
www.asonp.org/.

It has been said that Alaska has two seasons: winter and July. It has also been said that Alaska has mosquitoes the size of eagles and bears bigger than houses. In a land of extremes, even the art of exaggeration becomes,well—an art.

Alaska does indeed have four seasons, some longer than others, some never long enough. Each is a preamble to the next, as are seasons everywhere, but here they ebb and flow in luminous tides: brighter sunsets, deeper snows, colder nights, warmer stoves. Birds sing until midnight in summer and the northern lights can dance till noon in winter. That is no exaggeration. And the silence is so profound, so pure, and the space so open and free, it warms your heart—in any season.

Es heißt, daß Alaska zwei Jahreszeiten hat: Winter und den Juli. Das ist allerdings übertrieben.

Tatsächlich hat Alaska vier unterschiedlich lange Jahreszeiten; davon erscheinen manche nie lang genug . Wie überall ist jede der Vorbote der folgenden. Die Jahreszeiten haben ganz besondere Eigenschaften: leuchtendere Sonnenuntergänge, mehr Schnee, kältere Nächte, wärmere Öfen. Im Sommer kann man bis Mitternacht die Vögel singen hören und im Winter bis Mittag das Nordlicht am Himmel tanzen sehen. Das ist nicht übertrieben. Hier herrschen reine Stille und weite Landflächen. Alaska bringt Wärme ins Herz—zu jeder Jahreszeit.

アラスカには冬と7月のふたつの季節しかないと言われているが、これは誇張である。

アラスカには、四季がある。しかしそれらのなかには長いものもあれば、決して充分でないものもある。それぞれの四季が次のシーズンへのまえぶれであり、それはほかのどこともかわらない。アラスカの四季は特別である。光にあふれた日没、深い雪、寒い夜、あたたかいストーブ。夏には鳥達が真夜中までさえずり、冬には、オーロラが昼まで空を舞う。これは誇張ではない。ここでは、静けさがとても清らかで、スペースはそこ広く自由である。アラスカはどの季節もあなたのこころを暖かくくつろがせる。

春
Frühling

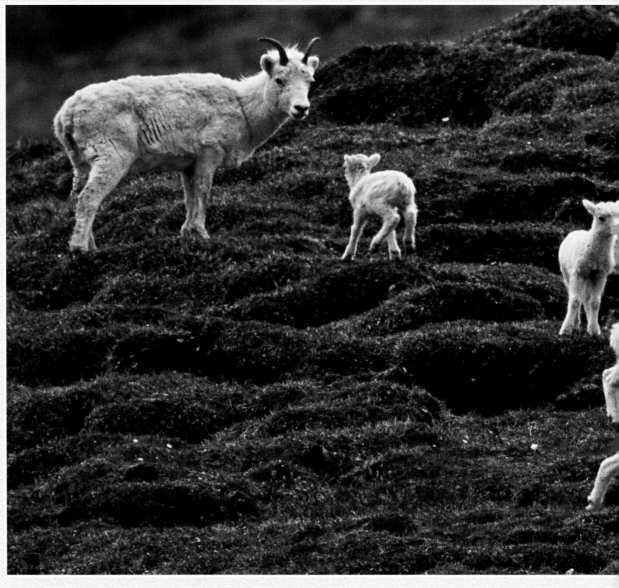

Spring

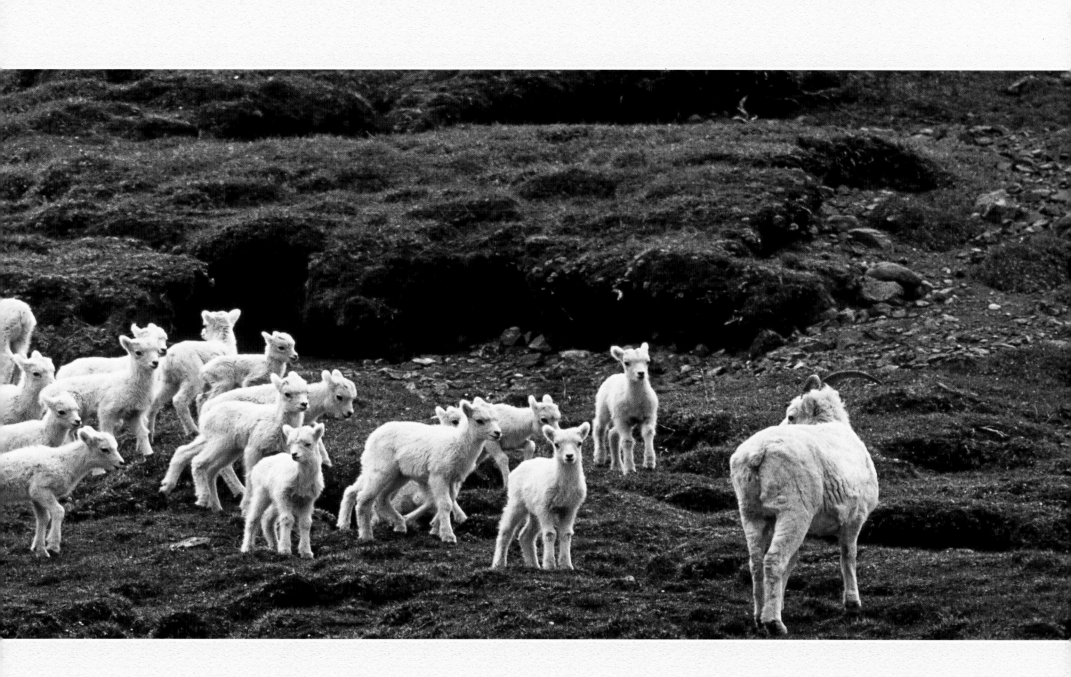

Dall's sheep, Denali National Park
(Dorothy Keeler)

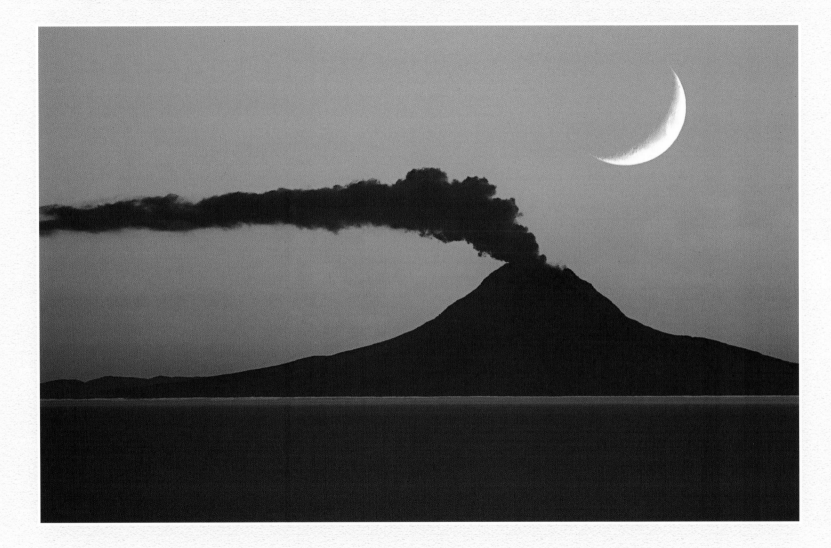

Spring

Spring brings promise, hope, optimism; flowers push up through snow, birds call on the wing, bears awaken in their dens. The rivers of Alaska, having been frozen for months, begin flowing in a grand spectacle called "spring breakup," when massive shards of ice buckle, splinter and shatter as they drift down current. Thousands of Alaskans place bets on precisely what day, hour and minute breakup will topple a tripod on the Tanana River in the town of Nenana. Most winners are between April 20 and May 10.

Daylight increases seven minutes a day. Molecules stir. Catkins and buds unfold. One day a tree appears brown, the next day it's outrageous green, like every other one of a thousand inventions of green that blanket mountain and valley, seashore and meadow, tundra and taiga.

Marsh marigolds and pasque flowers, the advance guard of hundreds of species to come, anoint south-facing slopes and forest floors. The sea, bathed in longer days, blooms with algae, shrimp and small fish—herring, capelin, sand lance—that will attract humpback whales from Hawaii, and millions of seabirds—puffins, auklets, cormorants, murres and gulls—to nest on storm-scoured cliffs. Other birds arrive from four continents, as well as from every state in the U. S. By early June, Alaska is riotous with life, hardly a silent spring, as the curtain opens on the most wondrous season of all—summer.

FACING PAGE Mount Augustine Volcano
(Steve Kaufman)

春

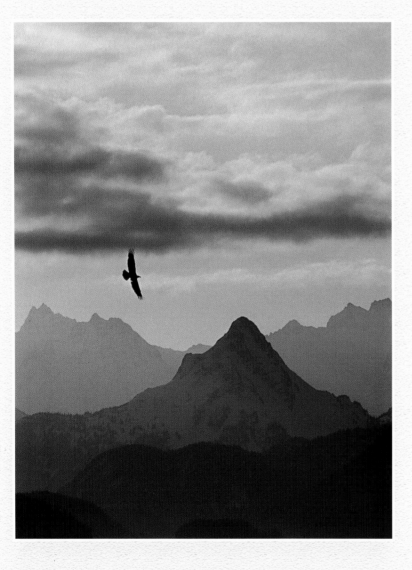

春は希望、約束、楽しさを運んでくる。雪の中から植物、花が顔を持ち上げ、鳥達が風にのり、熊達はそれぞれの穴蔵で目をさます。何ヶ月にも渡り凍り続けたアラスカの川は、「春のブレークアップ」とよばれる壮観のもとに流れ出す。巨大な氷の固まりが折れ曲がり、大きな音と共にこわれだし、そして海へと流れ出してゆく。

日照時間は１日に７分ずつ長くなってゆく。茶色だった木が翌日には緑に代わる。すぐに、たくさんの花が南向きの斜面そして森林に育つ。海もまた長時間にわたって太陽の光を浴び、海藻、海老、そしてハワイからの鯨を魅惑する小さい魚が育ち出す。鳥達が４つの大陸から到着する。百万のうみ鳥達が、崖に巣を作るため海を渡ってやって来る。６月のはじめまでに、待ちに待った最も驚きに満ちた季節ー夏と共に、生命が活発になる。

Frühling

Der Frühling bringt Erwartung, Hoffnung, Optimismus; die Blumen sprießen durch den Schnee, die Vögel singen im Flug, die Bären erwachen in ihren Höhlen. Nach monatelangem Frost beginnen Alaskas Flüße das große Schauspiel der Schmelze, das man hier " spring breakup" nennt. Massive Eisschollen biegen sich, brechen mit lautem Gekrache und treiben die Flüsse hinab zum Meer.

An jedem Tag verlängert sich das Tageslicht um sieben Minuten. An einem Tag noch braune Bäume zeigen sich am folgenden im grünen Kleid. Bald erscheint eine Blumenvielfalt an den Südhängen und im Wald. Mit wachsendem Tageslicht blühen im Meer die Algen. Die Buckelwale werden von dem großen Krebs–und Fischvorkommen von Hawaii zurückgelockt. Aus vier Kontinenten kehren die Zugvögel zurück. Millionen von Seevögeln sammeln sich an den Felsenhängen und bauen ihre Nester. Wenn der Juni kommt, ist Alaska erfüllt mit Leben in Erwartung auf die wunderbarsten Jahreszeit–den Sommer.

ABOVE Bald eagle in flight, Kenai Peninsula (Robin Brandt)

FACING PAGE Bald eagle soars above Kachemak Bay, Homer (Alissa Crandall)

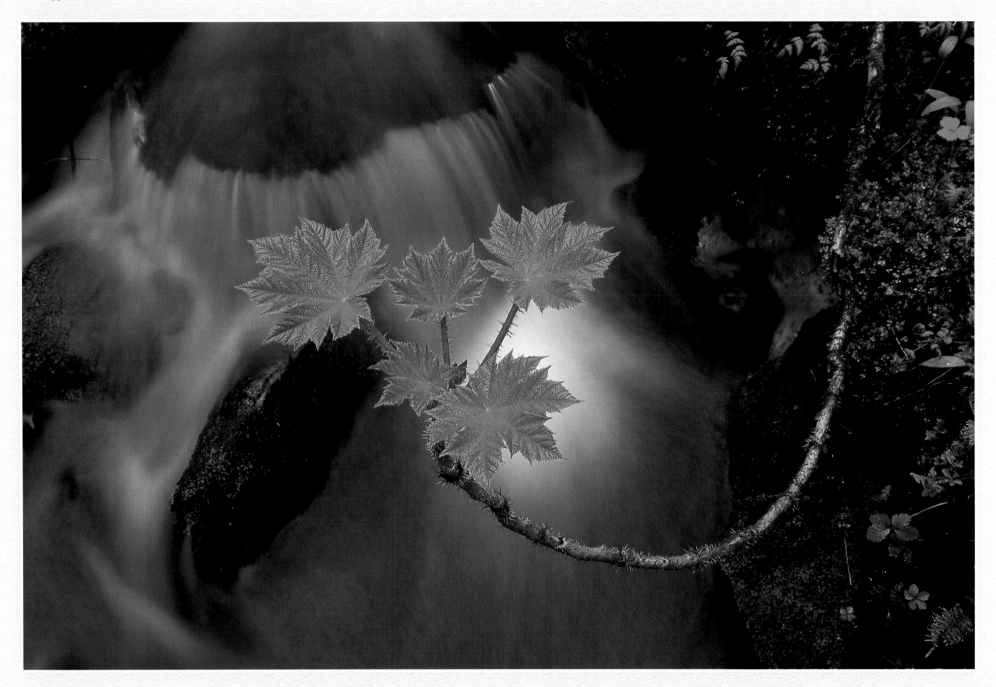

Devil's Club, Anchorage
(Calvin Hall)

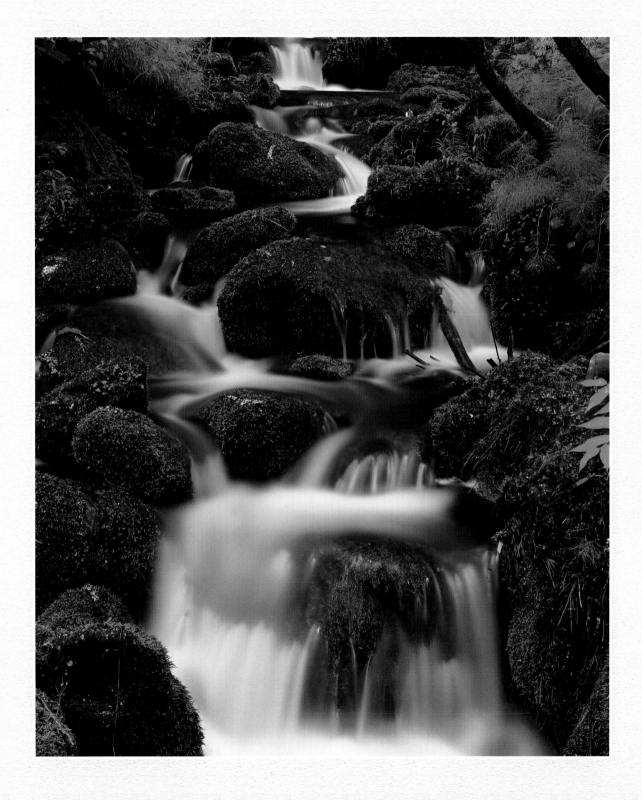

Cascading stream, Porcupine Creek,
Chugach National Forest
(Vance Gese)

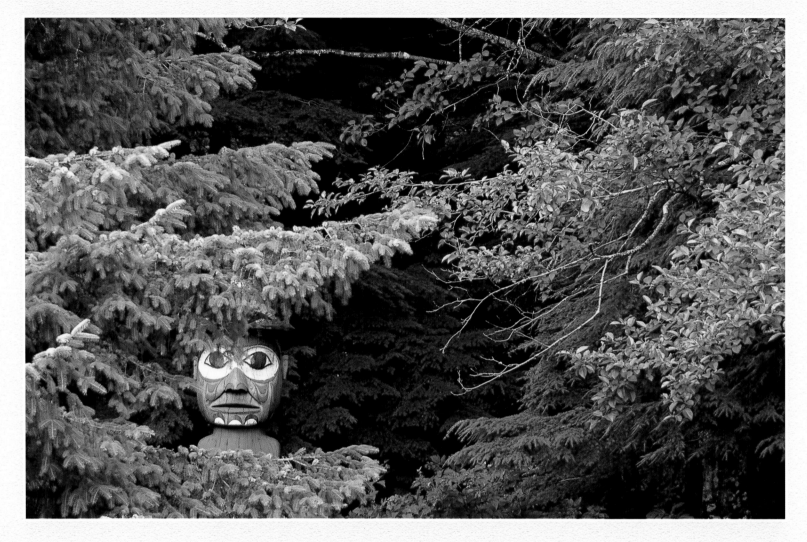

... tell your children that the earth is rich with the lives of our
kin. Teach your children what we have taught our children,
that the earth is our mother. Whatever befalls the earth
befalls the sons of the earth.

Chief Seattle to President Franklin Pierce

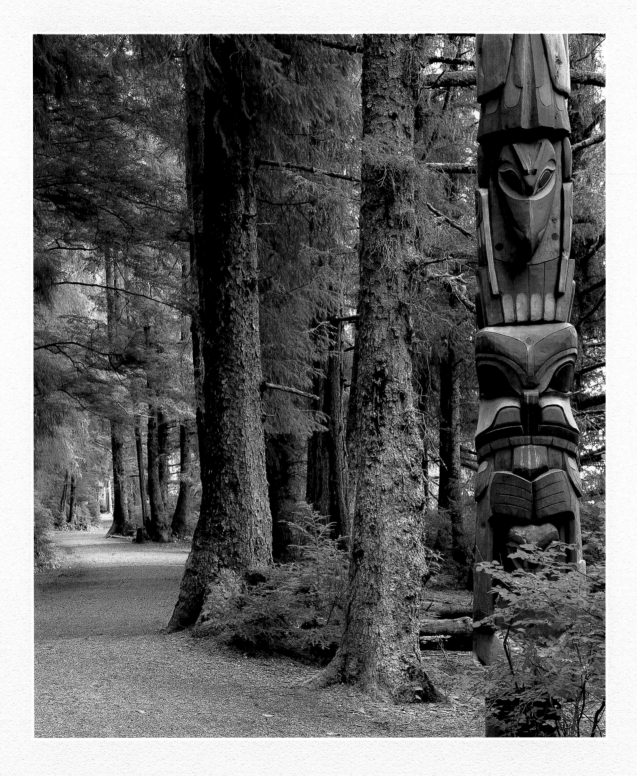

LEFT Yaadaas Crest Corner
Totem Pole, Sitka National
Historic Park
(Barbara Brundege)

FACING PAGE Totem,
Totem Bight State
Historical Park, Ketchikan
(Allen Kuhlow)

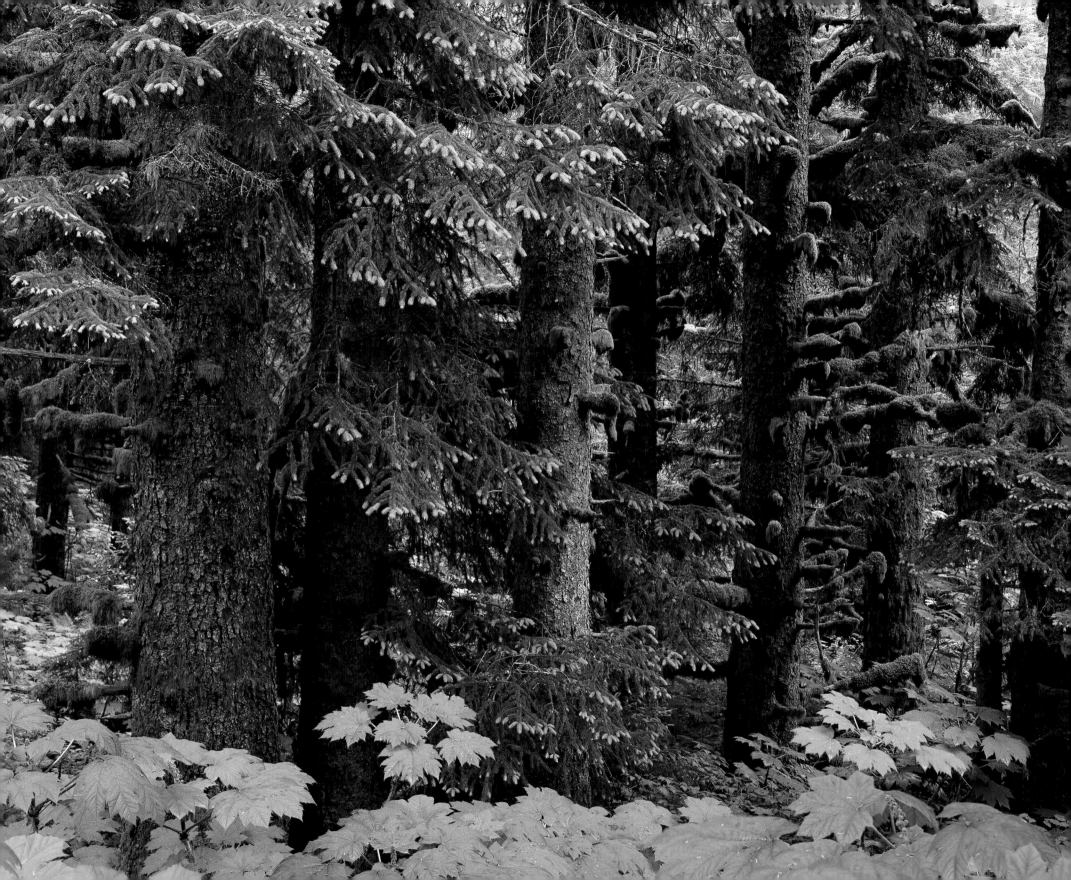

And everywhere it is green, life abounds...

Carey D. Ketchum
THE TONGASS: ALASKA'S
VANISHING RAINFOREST

green

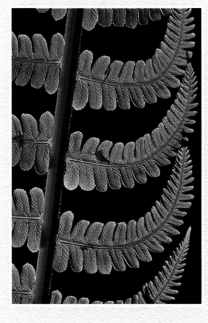

FACING PAGE Sitka spruce forest,
Ft. Abercrombie State Historical Park,
Kodiak (Jeff Gnass)

LEFT Ostrich fern detail,
Trapper Creek (Jon Nickles)

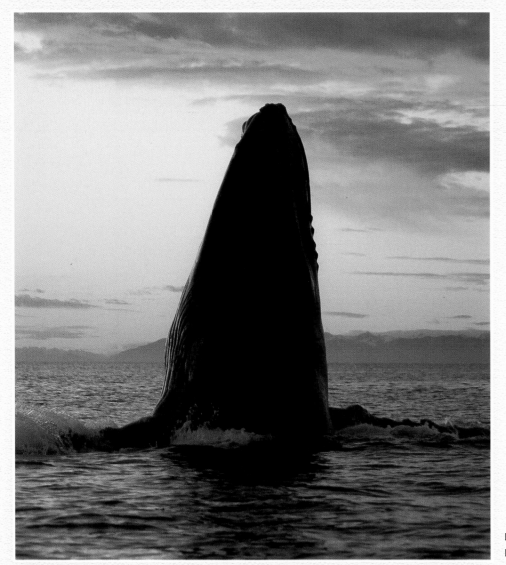

Humpback whale "spy hopping" at sunset,
Frederick Sound (Barbara Brundege)

nations

Animals are not brethren,
they are not underlings;
they are other nations,
caught with ourselves
in the net of life and time.

Henry Beston

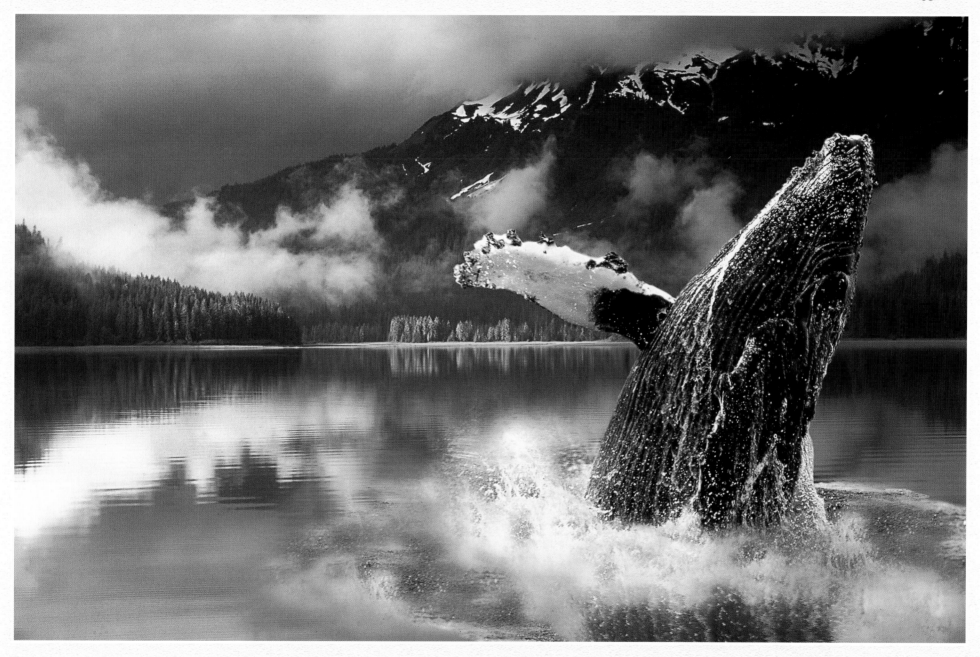

Whale breeching in Southeast Alaska
(composite image by Ron Sanford/Alaska Stock)

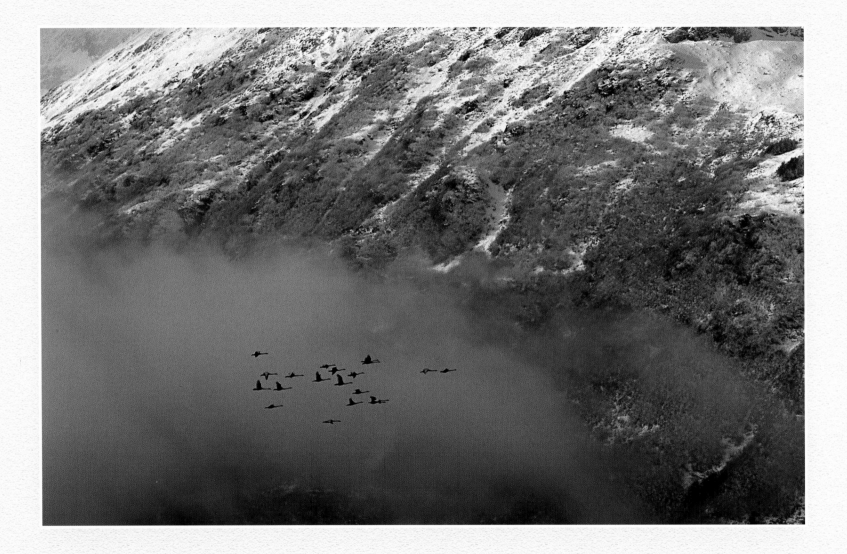

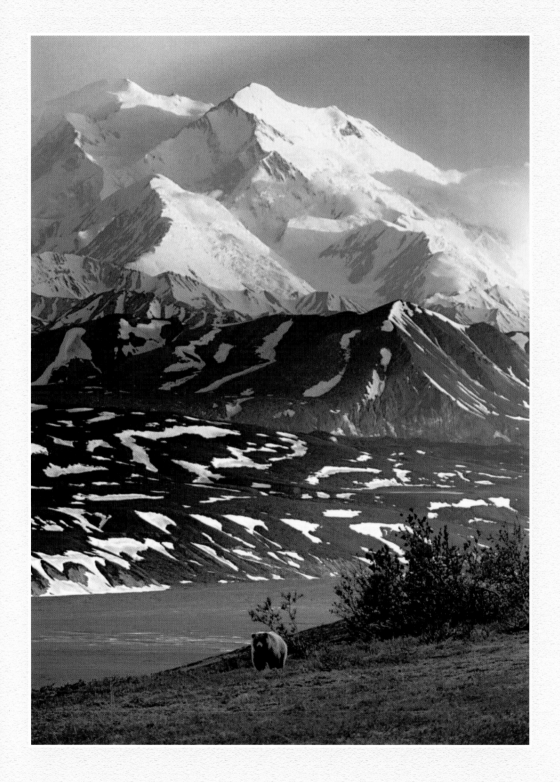

I feel inept and frail, seeing these animals,
whose everyday world is beyond my reach or
comprehension. They find security and ease
where I would never survive, drawing on
capacities vastly different from my own
but no less perfected.

Richard Nelson
THE ISLAND WITHIN

survival

LEFT Grizzly bear and
Mt. McKinley, Denali
National Park
(Leo Keeler)

FACING PAGE Migrating
birds, Portage
(John Toppenberg)

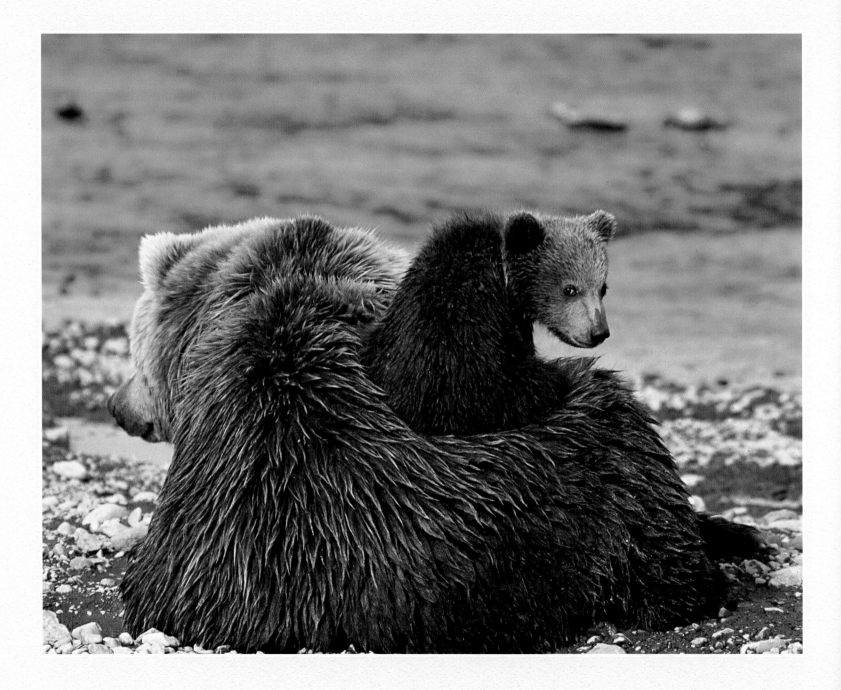

RIGHT Coastal brown bear sow
and cub, Katmai National Park
(Tony Dawson)

FACING PAGE Nursing brown bear,
McNeil River State Game Sanctuary
(Gary Schultz)

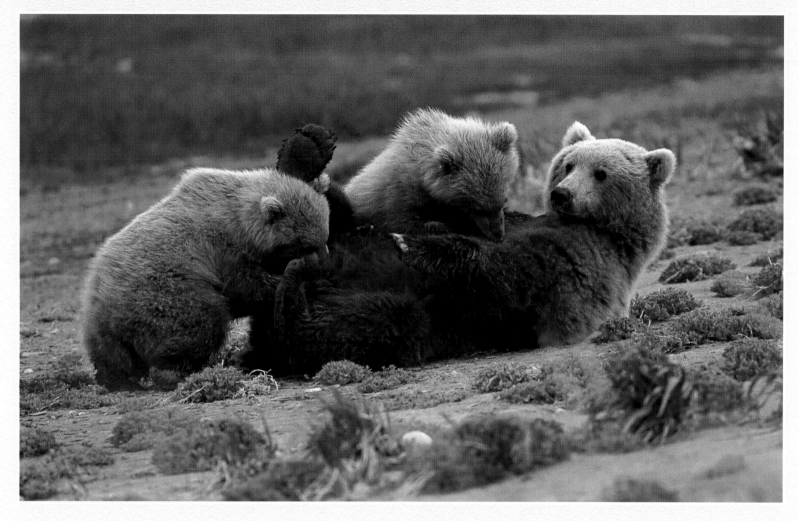

We need the wilderness... to inspire us, to put our
lives at risk, to humble us. And, more important,
the bears need it too.

humility

Reed Noss
WILD EARTH

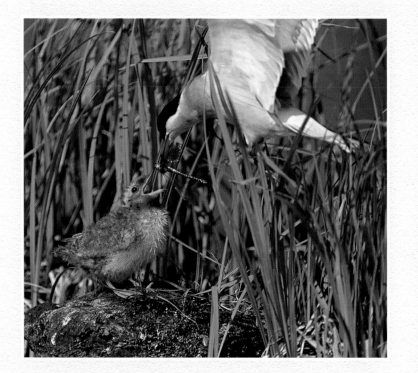

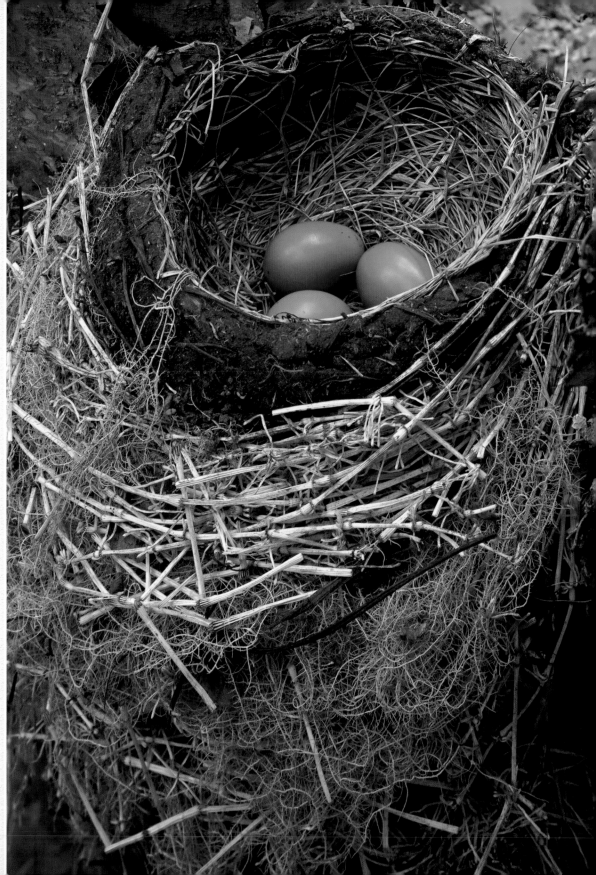

LEFT Nesting tern, Anchorage
(Gary Lackie)

RIGHT Nest of American Robin, Matanuska
Valley (Fred Hirschmann)

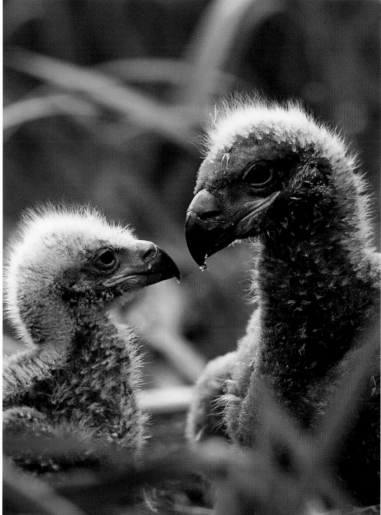

LEFT Detail of seagull feather
(Calvin Hall)

RIGHT Baby eaglets, Southwest Alaska
(Lon Lauber)

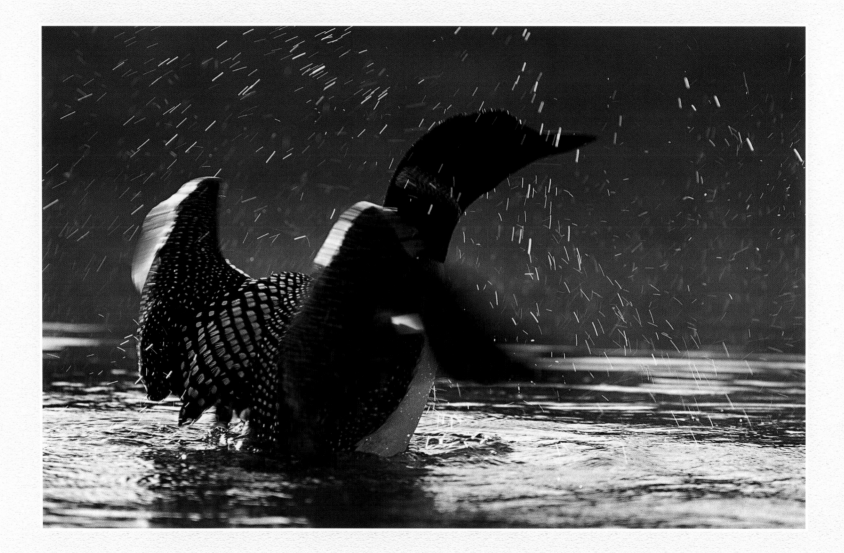

ABOVE Loon, Kenai Peninsula
(John Toppenberg)

FACING PAGE Snowy owl, Arctic National
Wildlife Refuge (Steve Kaufman)

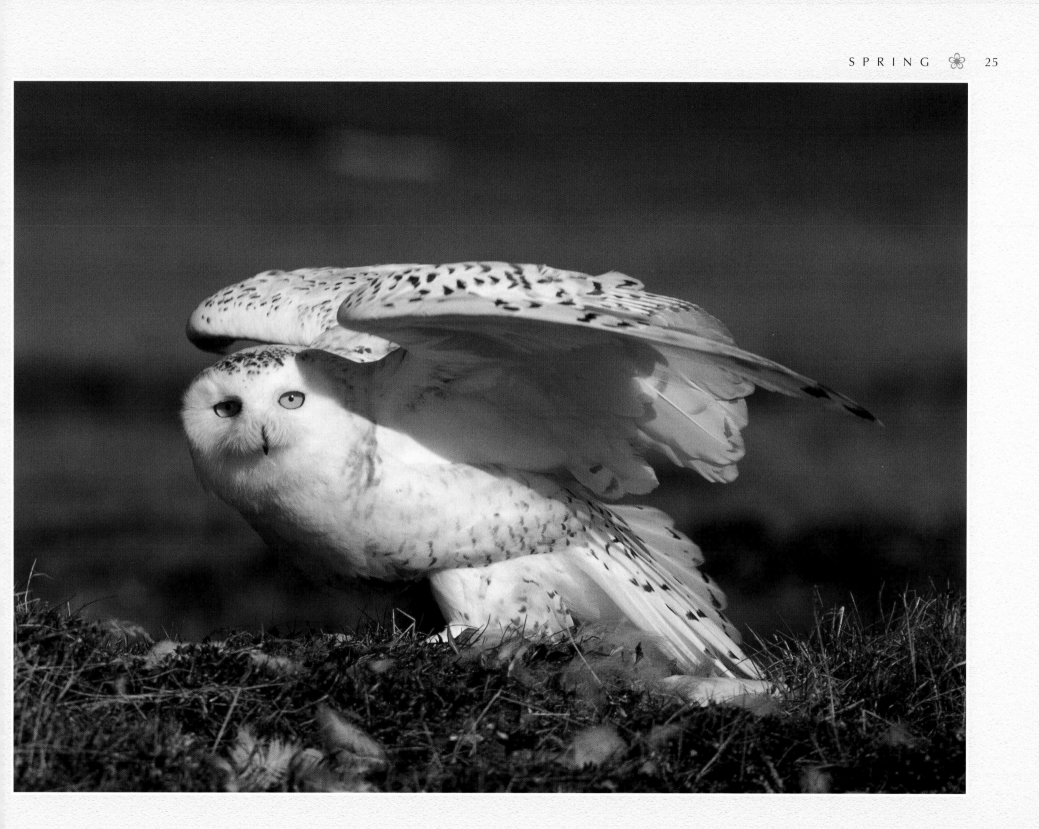

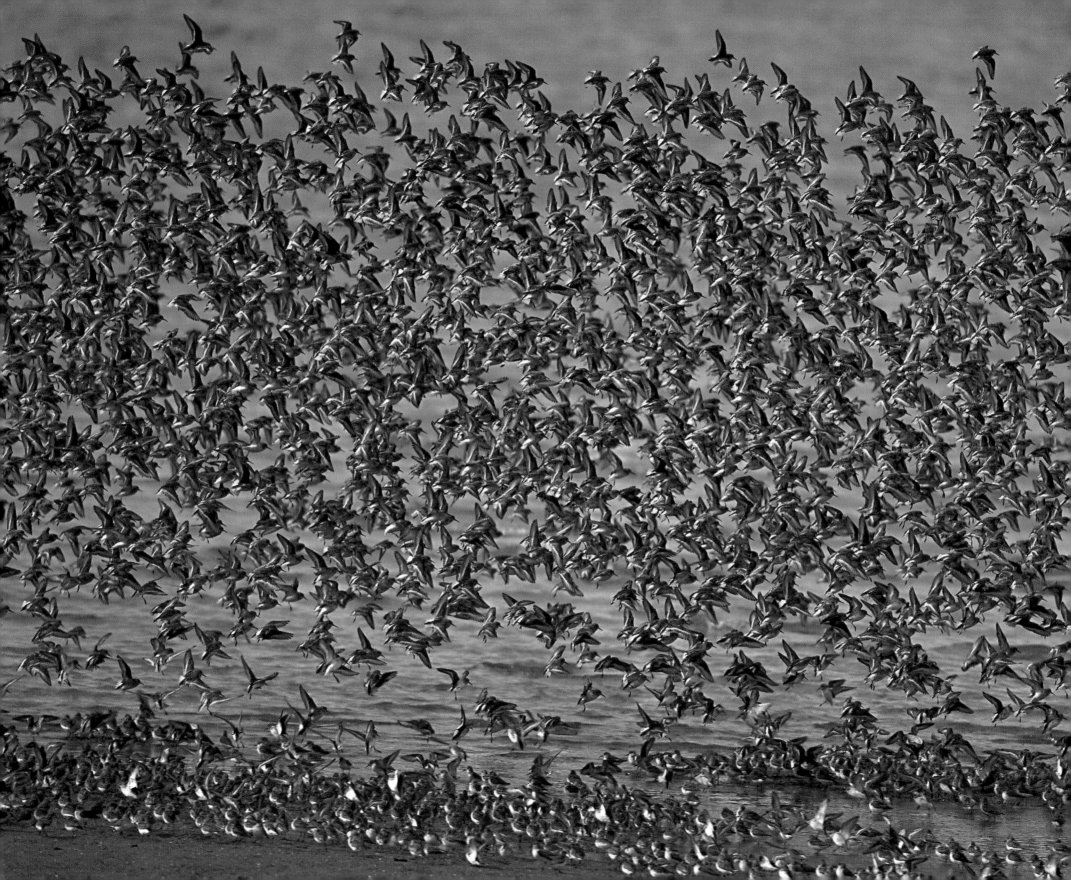

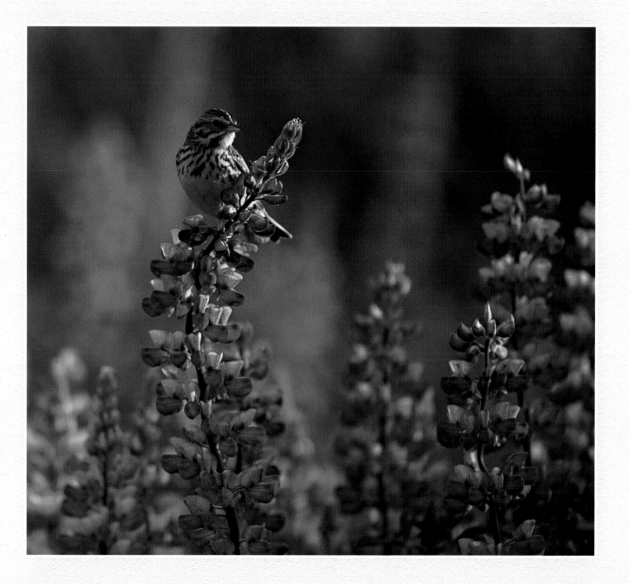

spring

There is symbolic as well as actual beauty
in the migration of birds, the ebb and flow of tides,
the folded bud ready for spring.

Rachel Carson
THE SENSE OF WONDER

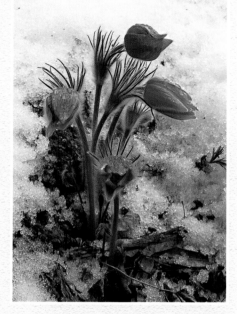

LEFT Migrating shorebirds, Copper River Delta,
Cordova (Steve Kaufman)

ABOVE White-crowned sparrow and lupine,
Turnagain Arm (Jo Overholt)

RIGHT Pasqe flower, Nenana River (Tom Walker)

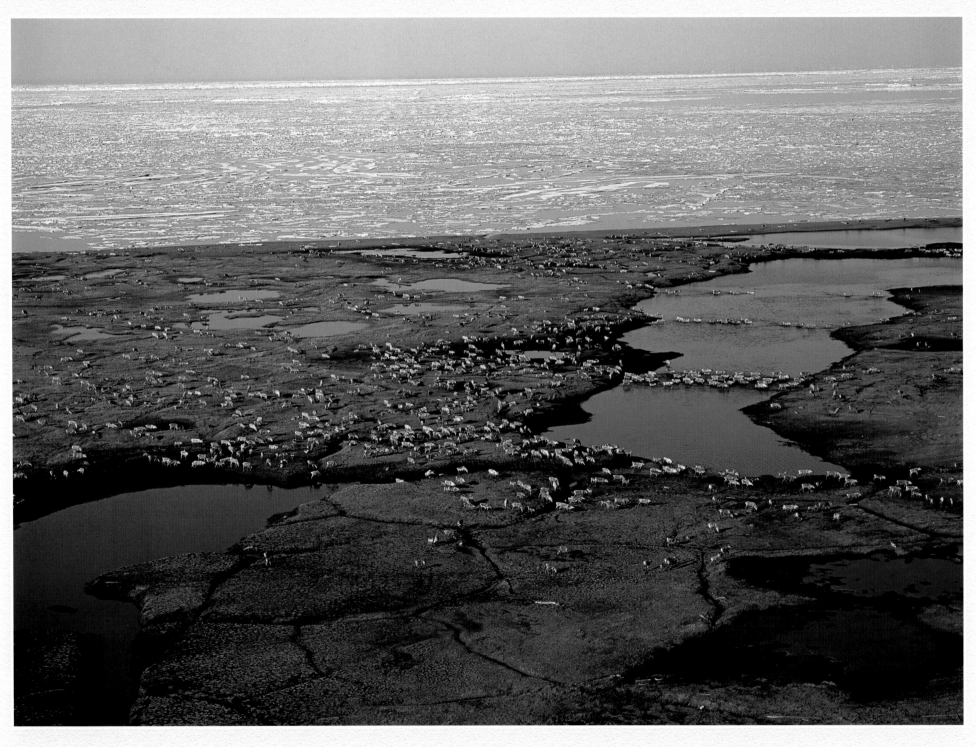

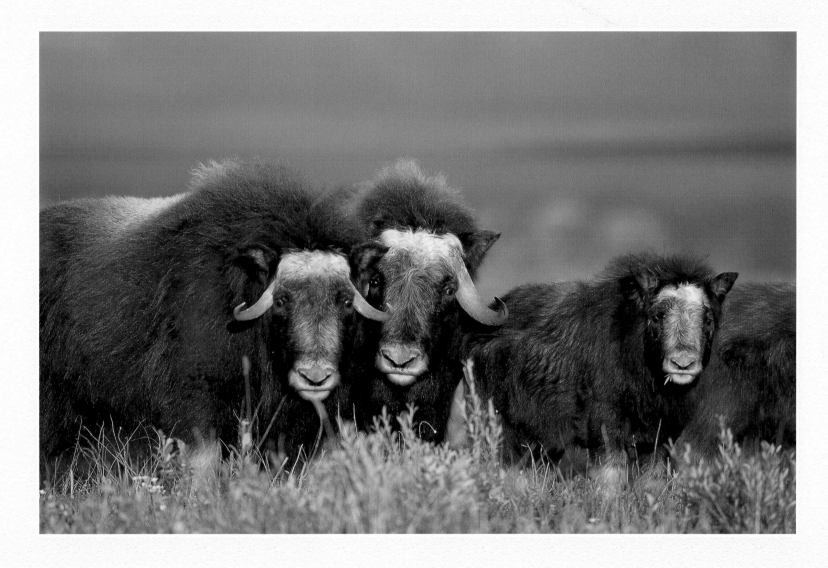

ABOVE Muskoxen, Arctic National
Wildlife Refuge (Hugh Rose)

FACING PAGE Porcupine caribou herd along the
Beaufort Sea coastline, Arctic National
Wildlife Refuge (Tony Dawson)

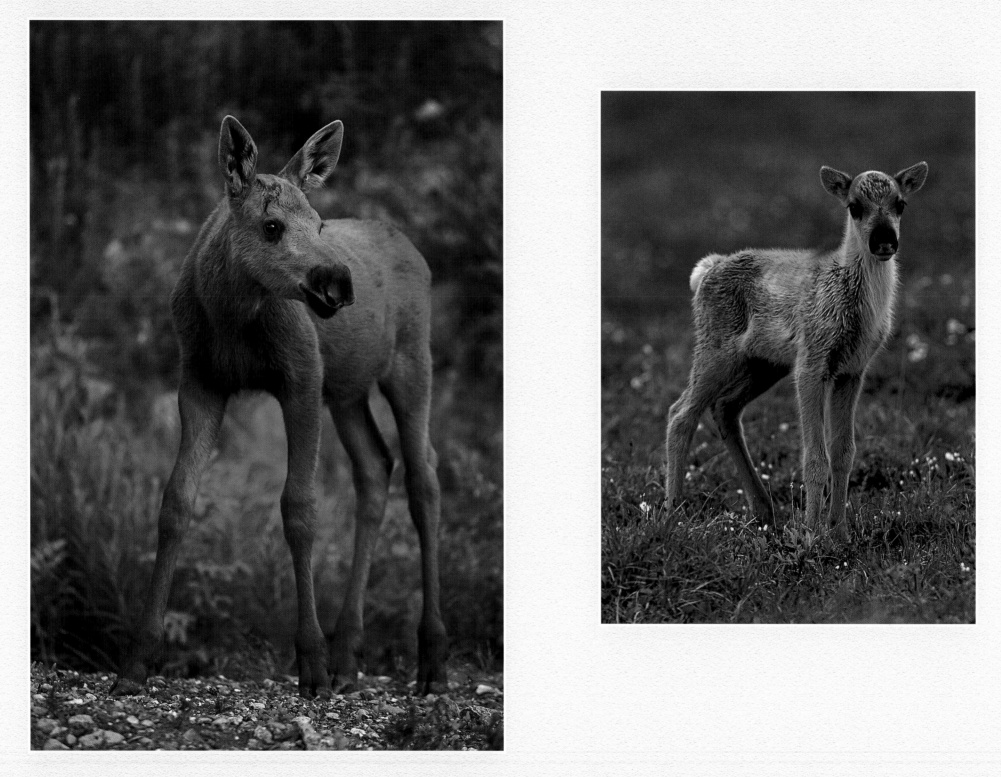

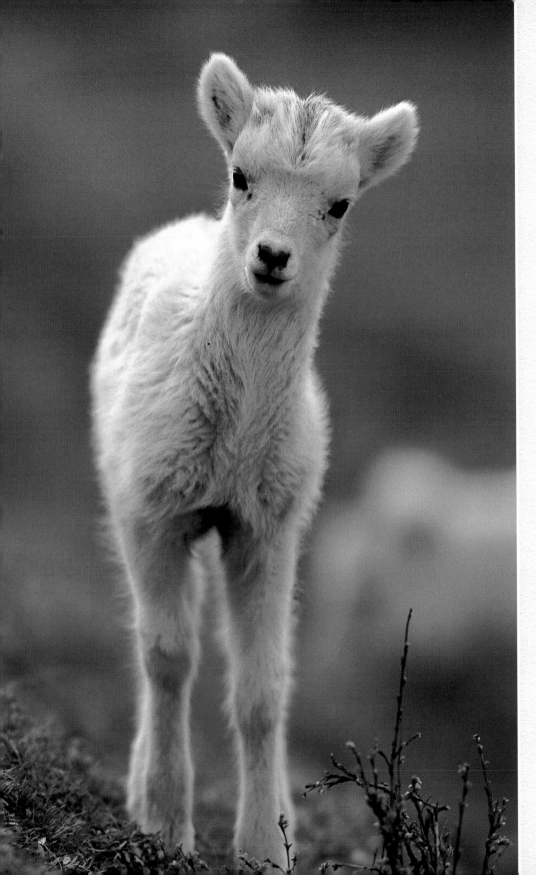

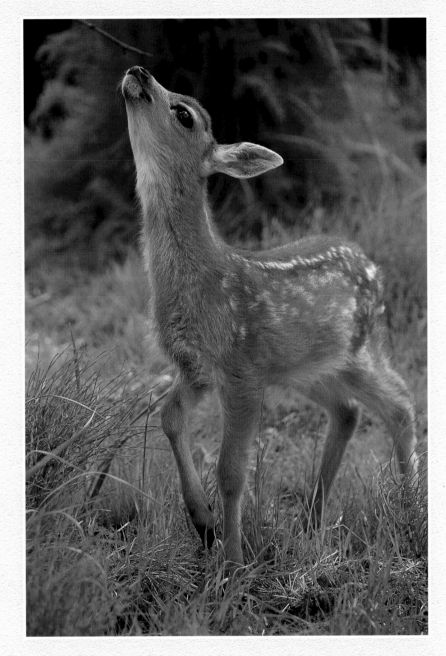

FACING PAGE, LEFT Baby moose, Denali National Park (Robin Brandt)
FACING PAGE, RIGHT Baby caribou (Kim Heacox)
ABOVE LEFT Dall's sheep lamb (Craig Brandt)
ABOVE RIGHT Sitka black-tailed deer fawn (Alissa Crandall)

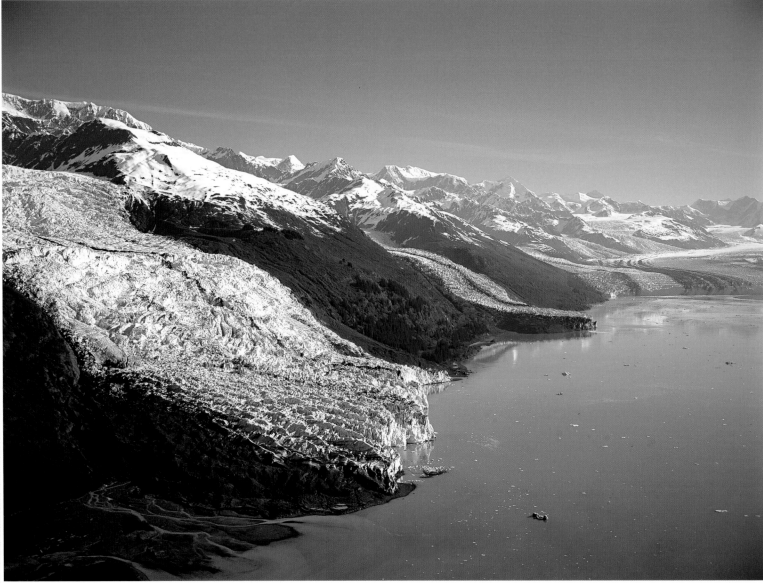

 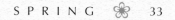

The wide ceaseless sweep of a live glacier
down the side of a great mountain
and out into the sea holds
a more compelling suggestion of power
than any other action of nature.

Ella Higginson
ALASKA, THE GREAT COUNTRY

power

LEFT Icewater melt pond,
Juneau Icefield
(John Hyde)

FACING PAGE Chugach Mountains
and College Fjord,
Prince William Sound
(Greg Probst/Accent Alaska)

presence

Few things provoke like the presence of wild animals.
They pull at us like tidal currents.

Barry Lopez
ARCTIC DREAMS

RIGHT Sea shells and green sea
urchins, Prince William Sound
(Michael O'Connor)

FACING PAGE Sea otters
(John Warden/Alaska Stock)

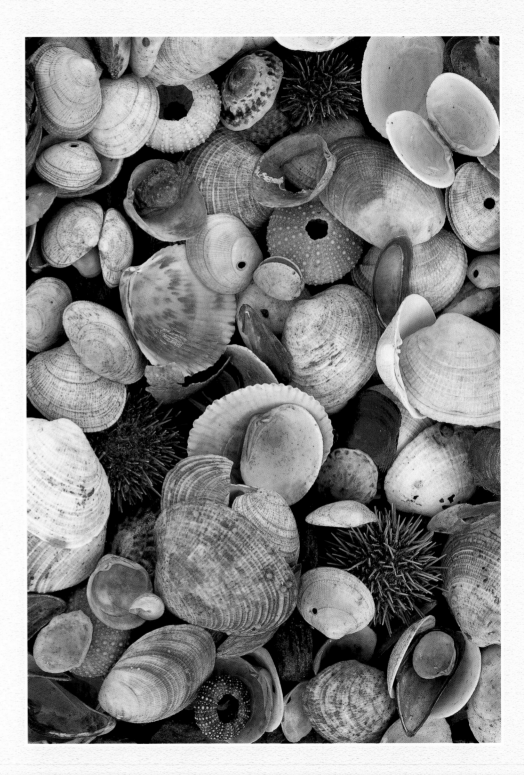

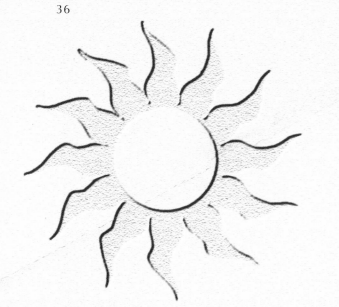

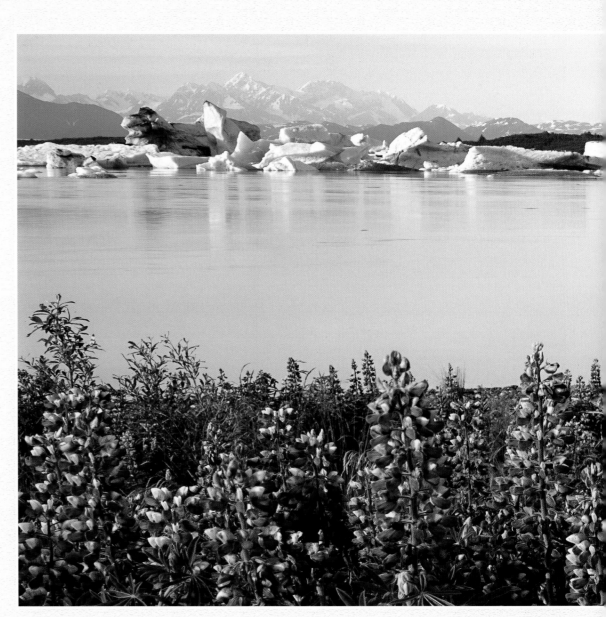

Summer

夏 Sommer

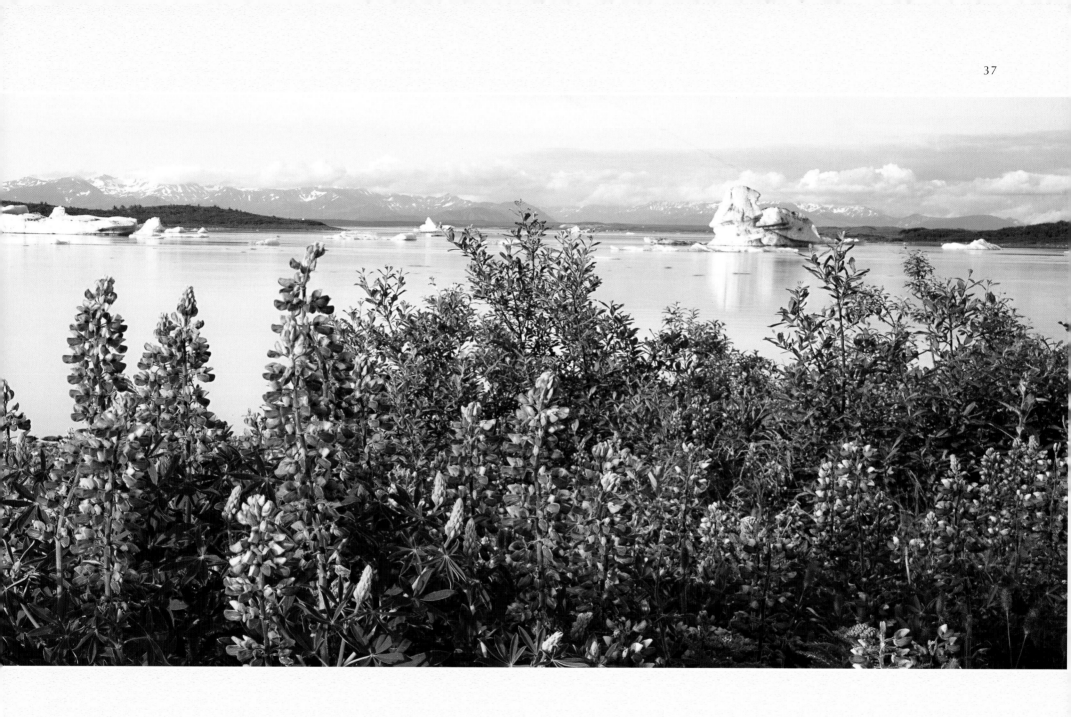

Summer wildflowers near
Bering Glacier (Jeff Gnass)

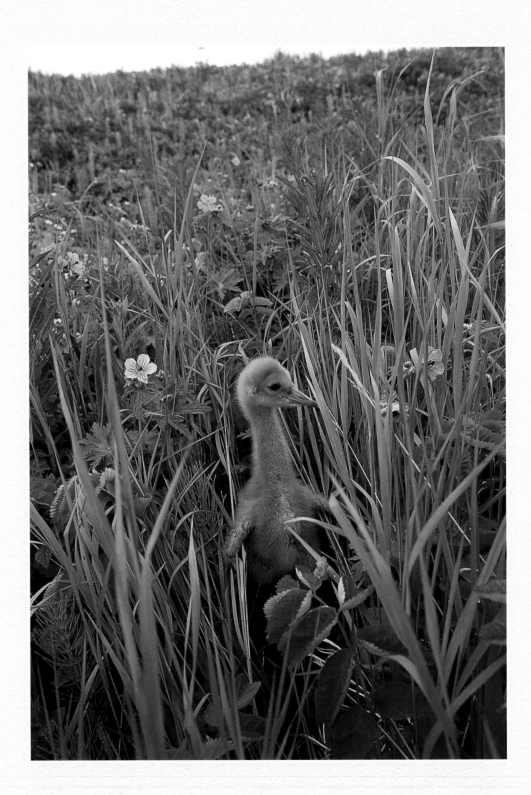

RIGHT Sandhill crane chick, Dillingham
(Tom Soucek)

FACING PAGE Mountain avens, Denali
National Park (Patrick Endres)

Summer

Summer, short but sweet, reminds all Alaskans why they live here. Every minute of every summer day is a precious elixir that adds youth, invites adventure and gives purpose to life in the out-of-doors. The arctic sun, absent in winter, stays up all night in the northern part of the state, as do arctic residents playing baseball in Barrow at 3:00 a.m. or basketball in Kotzebue at midnight.

Light floods the land in vibrant spokes of cinnabar, sienna, ocher and gold. Wildlife bring forth a new generation of young: sandpipers on the tundra, thrushes in the forests, loons on the lakes, a mother moose with newborn twins, a caribou herd with 10,000 new calves. They eat constantly to add weight for the coming winter.

Constellations of wildflowers splash over tundra and meadow, up scree slopes and astride rivers.

All five species of the Pacific salmon—king, coho, sockeye, pink and chum—return from the sea to spawn in the rivers from whence they came. They number in the millions and churn streams from bank to bank. And with them return the fisherfolk, male and female, two-legged

and four-legged, some with rod and reel, some with paw and claw, hungry to catch the biggest fish they can.

Tourists arrive in numbers that dwarf the Klondike Gold Rush of 1897-98, for they've come this time not for gold or fish or oil, but for the scenery of wild Alaska: tidewater glaciers and harbor seals off the deck of their cruise ship, grizzly bears and Dall's sheep from the window of their bus, bald eagles and ravens from the door of their hotel. Alaska's bounty is its greatest summer salutation. So delicious, so blessed, such a gift. It never lasts long enough. But it always returns.

夏

夏は短く、この季節はアラスカンになぜここに暮らしているかを思い出させる。夏の毎日の一分一分がとても貴重で、アドベンチャーへと誘いをかけ、アウトドアでの生活が意味をもたらす。冬には見えない北極の太陽が、アラスカの北部では１日中見ることができる。北極圏の住人も、バローで午前３時に野球を、コツェビューでも真夜中にバスケットボールをすることができるのだ。

様々の色の光りが大地を照らす。動物達は次の世代へと生命をもたらし、次に来る冬に備えて食べに食べる。野生植物がツンドラ、湿地を被い、山の斜面や川沿いに花を咲かせる。

百万もの大平洋からのサーモンが、産卵の為に生まれたのと同じ川に戻ってくる。たくさんのサーモンが、こちらの岸からあちらの岸まで川をうめる。そして、人間、動物たちが、それぞれの見つけうる一番大きな魚をとりに戻ってくる。

旅行者の数は、１８９７－９８年のゴールドラッシュ時の金探掘者の数をこえる。人々は金を求めてはいないが、壮観を求めてやってくる。海へとつづく氷河、クルーズ船のデッキごしに見えるアザラシ、バスの窓から見えるグリズリーベアやドールシープ、ホテルのドアから見えるはげわしや、カラスの姿といったようなものを。アラスカが受ける恩恵は、夏のすばらしい贈り物だ。それは決して充分な長さではないが、かならず戻ってくる。

Sommer

Der Sommer ist kurz. Die Bewohner Alaskas fühlen sich durch ihn in der Wahl ihres Wohnsitzes bestärkt. Im Sommer ist jede Minute kostbar, lädt zum Abenteuer und zum Erlebnis in der Natur ein. Die im Winter abwesende Sonne steht im Norden des Staates rund um die Uhr am Himmel. In Barrow oder Kotzebue können die Menschen noch um 3 Uhr morgens Baseball oder Basketball spielen.

Das Land erscheint in vielen verschiedenen Lichtfärbungen. In der Tierwelt wird eine neue Generation geboren. Als Vorrat für den kommenden Winter müssen sie ununterbrochen Nahrung sammeln. Tundra und Wiesen sind mit Wildblumen übersät. Sie blühen an den Berghängen und an den Flußufern.

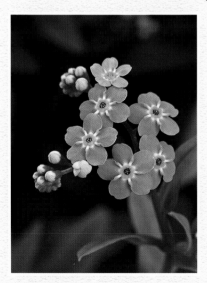

Millionen Pazifiklachse kehren von der See zu den Laichplätzen ihrer Geburt zurück. Sie sind so zahlreich, daß sie die Flüße von Ufer zu Ufer füllen. Gleichzeitig kehren auch Menschen und Tiere zurück begierig darauf möglichst große Fische zu angeln.

Der Touristenstrom Übertrifft den der Goldsucher zur Zeit des Klondike Goldrausches im Jahr 1897-98. Heute kommen die Menschen nicht des Goldes sondern der Landschaft wegen: Gletscher auf Meeresebene und Seehunde, die sie von Bord der Kreuzfahrtschiffe, Braunbären und Dall-Schafe, die sie vom Reisebus aus, sowie Seeadler und Raben, die sie von ihrem Hotel aus beobachten können. Alaskas Vielfalt und Reichtum sind das größte Geschenk des Sommers. Er ist nie lang genug, aber er kehrt immer wieder.

Forget-me-not
(Alaska state flower),
Anchorage (Cathy Hart)

travelers

We are all travelers in the wilderness
of this world, and the best we can find
in our travels is an honest friend.

Robert Louis Stevenson

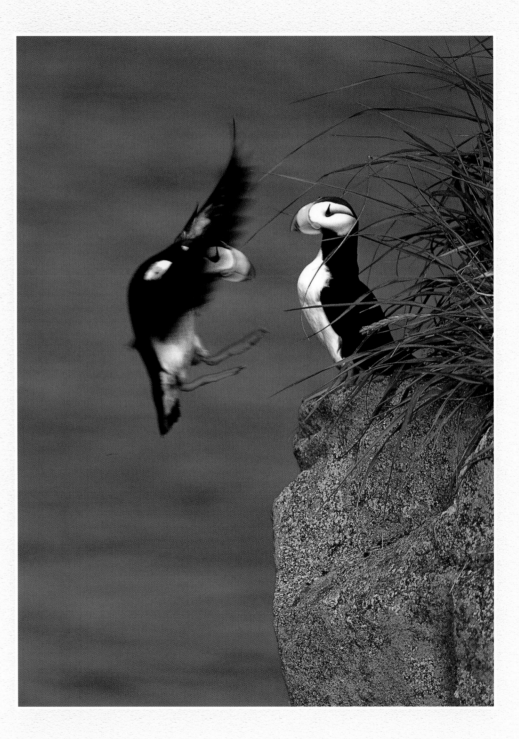

Horned puffins,
Round Island
(Gary Schultz)

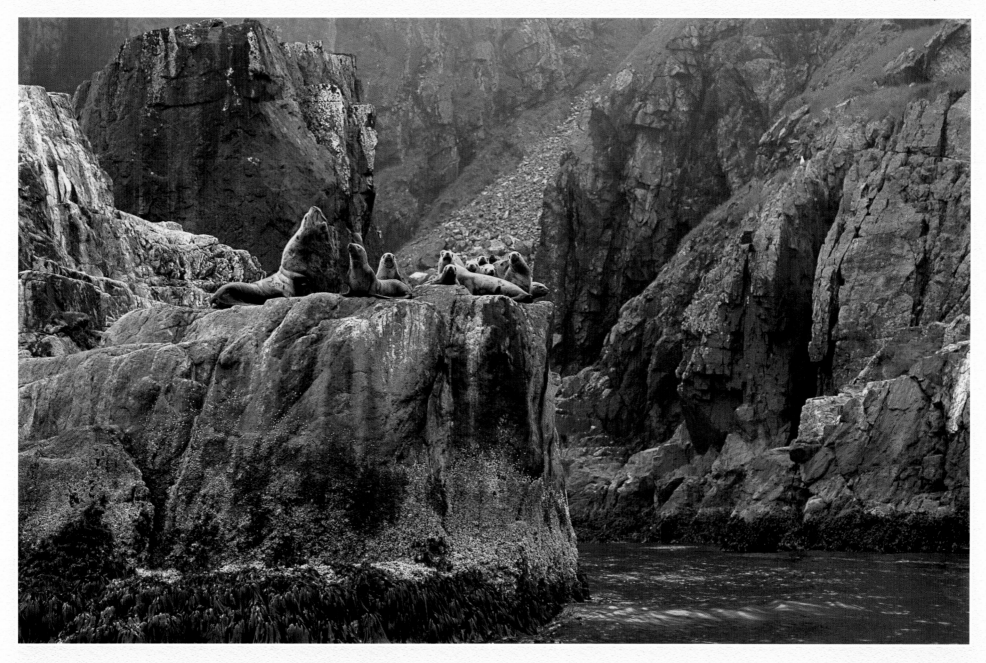

Northern sea lions,
Southwest Alaska
(Lon Lauber)

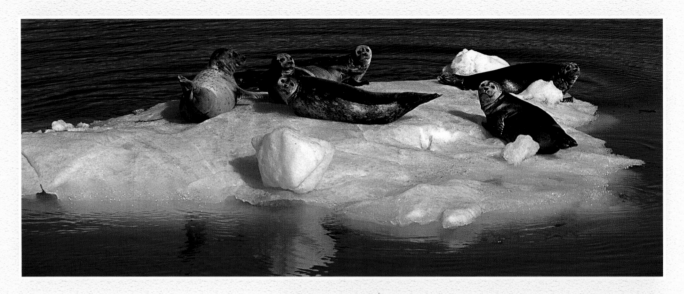

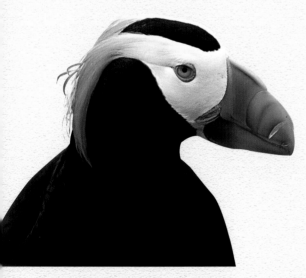

ABOVE Seals on iceberg,
Prince William Sound
(Alissa Crandall)

RIGHT Crested auklets,
St. George, Pribilof Islands
(Alissa Crandall)

LEFT Tufted puffin,
St. Paul, Pribilof Islands
(Alissa Crandall)

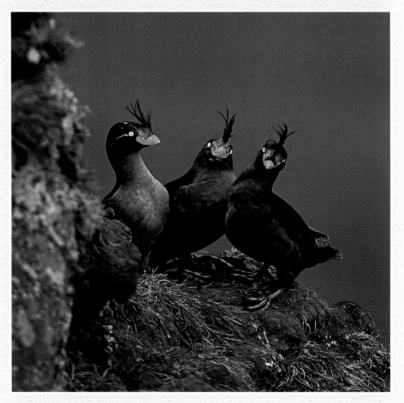

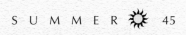

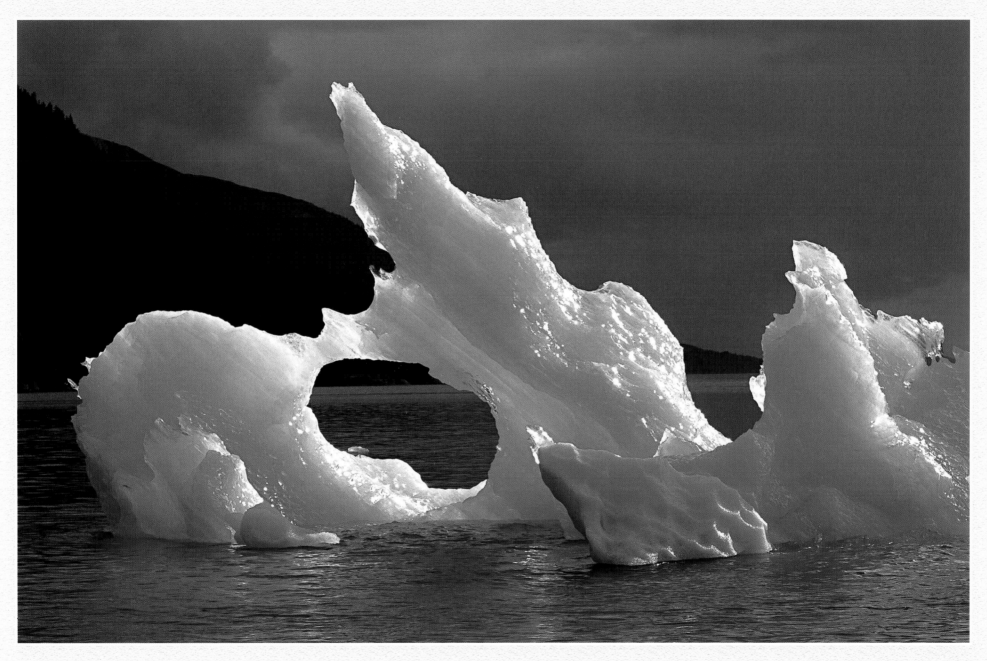

Iceberg,
Prince William Sound
(Tom Walker)

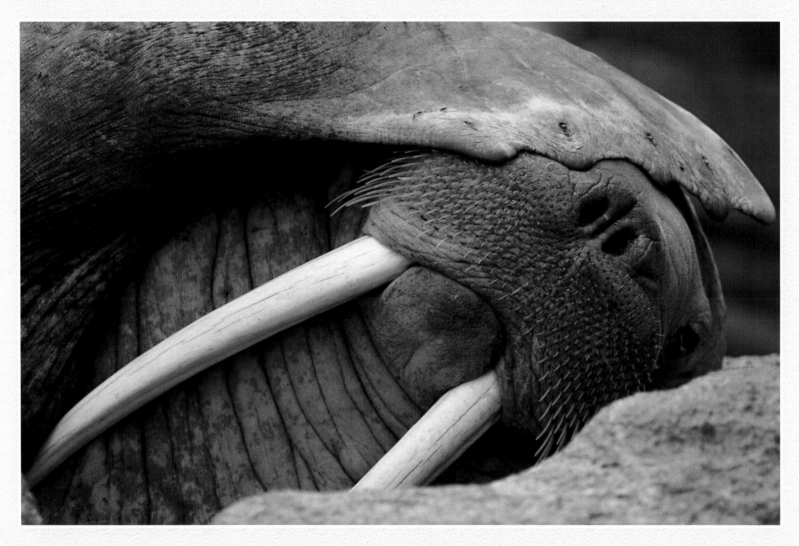

ABOVE Walrus, Round Island
(Alissa Crandall)

FACING PAGE, left
Walrus beach, Round Island
(Lon Lauber)

FACING PAGE, right
Walrus, Round Island
(Gary Lackie)

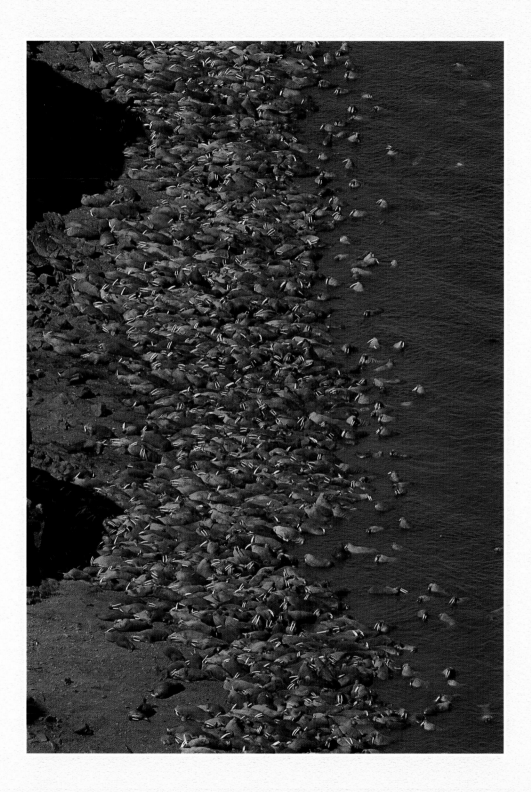

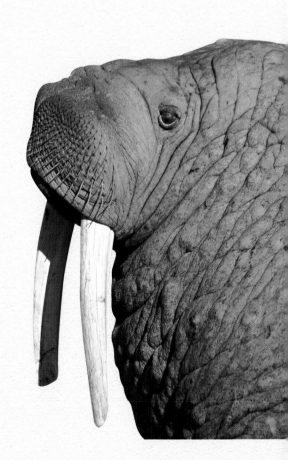

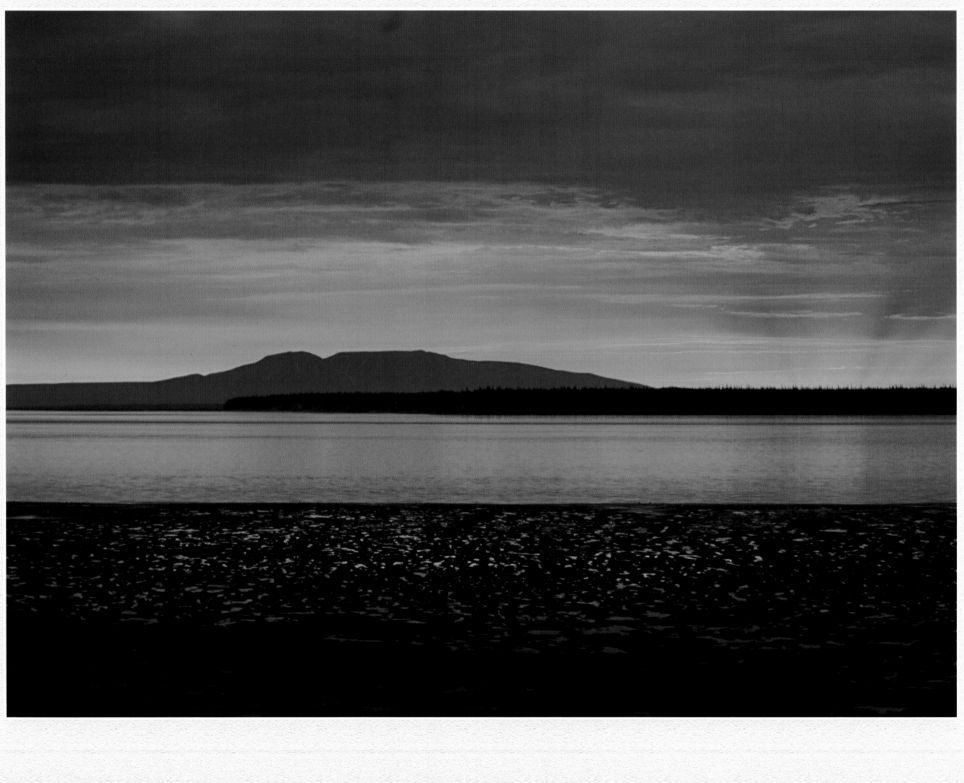

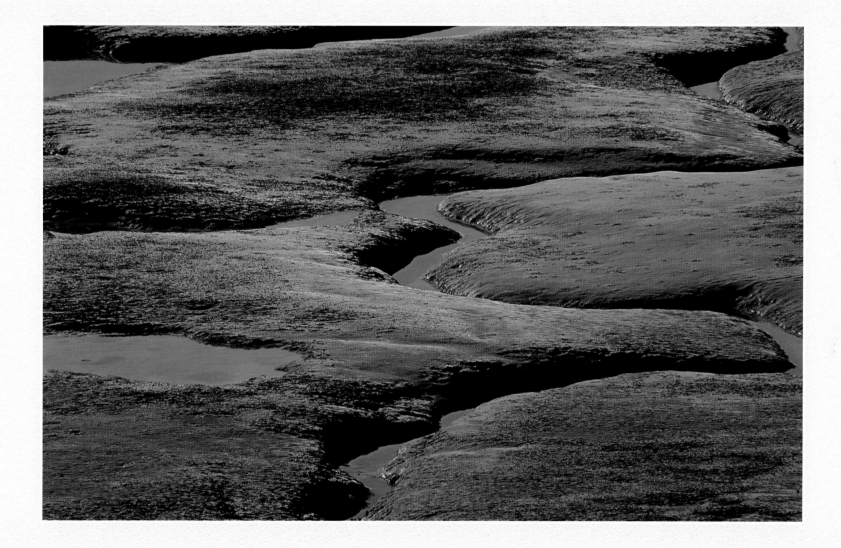

ABOVE Algae on mudflats, Turnagain Arm
(Ron Niebrugge)

FACING PAGE Mount Susitna and tide flats,
Anchorage (Todd Salat)

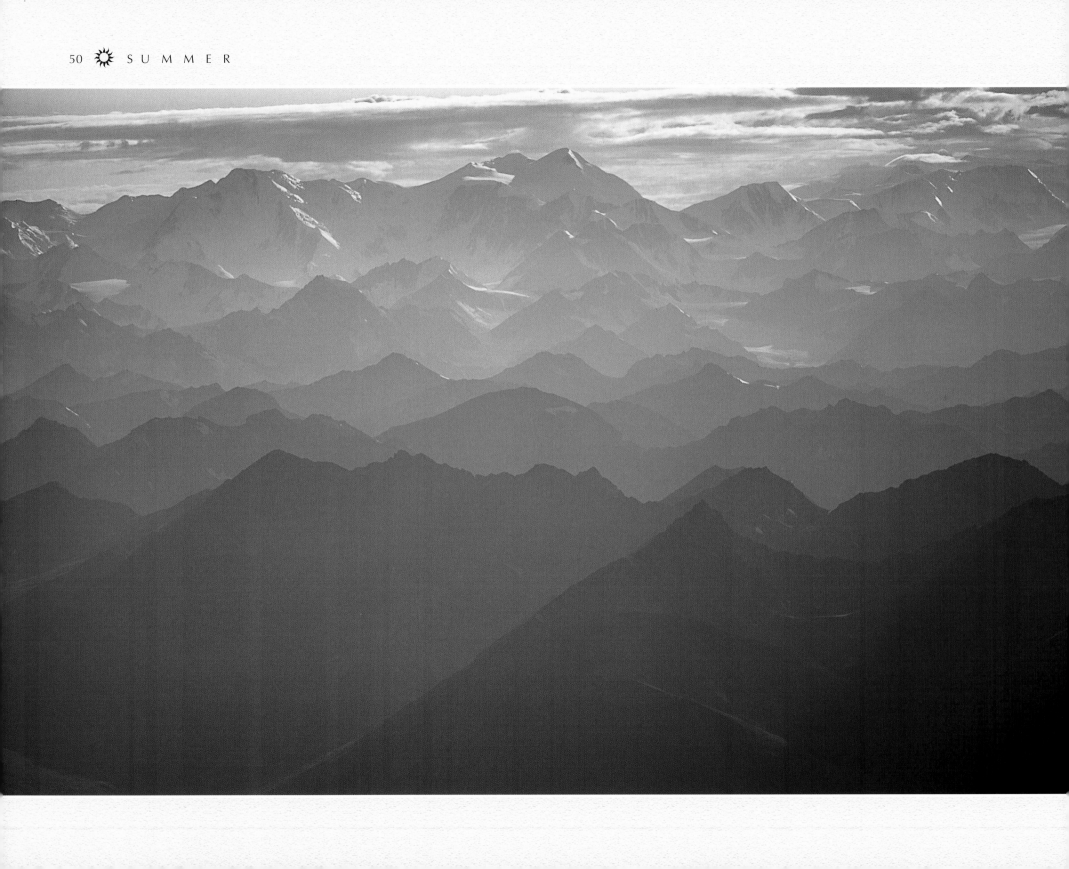

mountains

Mountains are the beginning and the end
of all natural scenery.

John Ruskin
MODERN PAINTERS

LEFT Chugach Mountains
(Myron Wright/Alaska Stock)

RIGHT Lichen-covered tundra,
Brooks Range (Vance Gese)

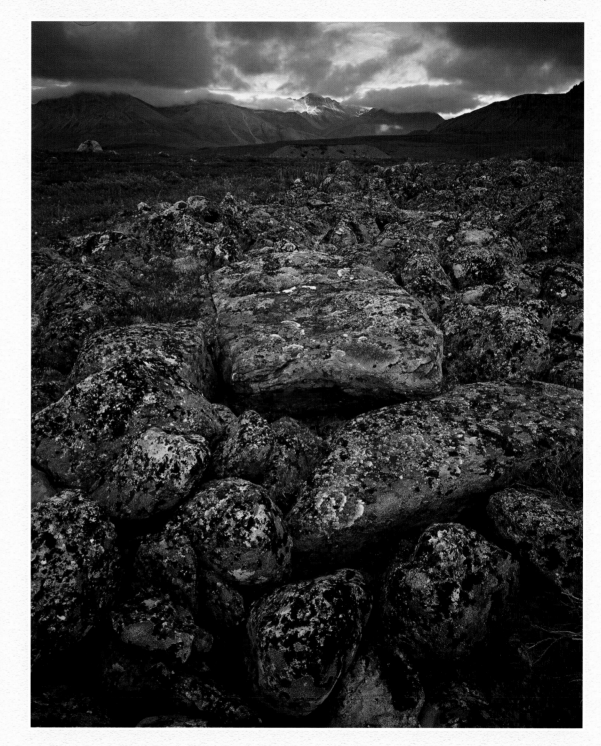

One day's exposure to mountains is better
than cartloads of books.
See how willingly Nature poses herself
upon photographers' plates. No earthly
chemicals are so sensitive as those
of the human soul.

John Muir

nature

RIGHT Cathedral Spires,
Denali National Park (Myron Wright)

FACING PAGE Moose rendezvous in Wonder Lake,
Denali National Park (Cliff Riedinger)

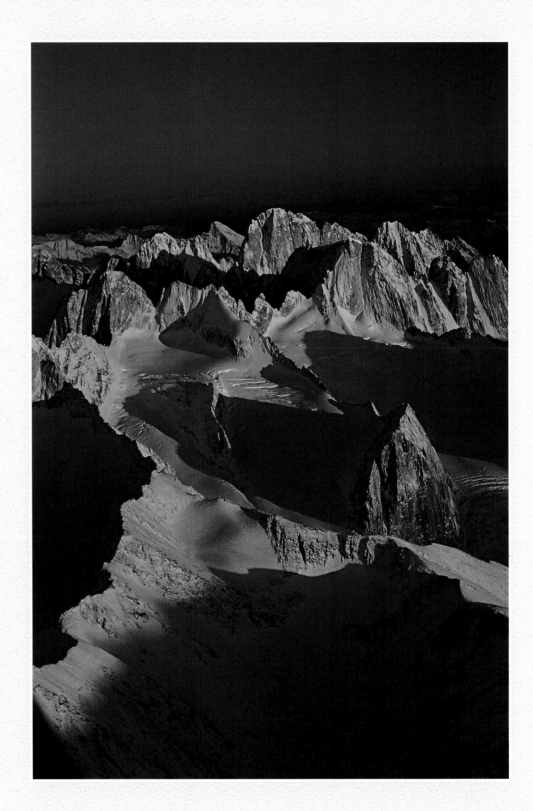

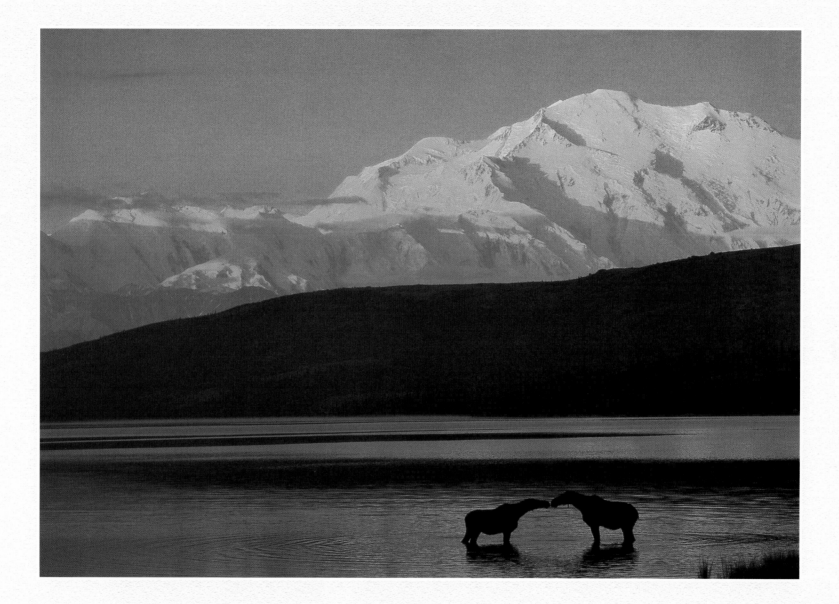

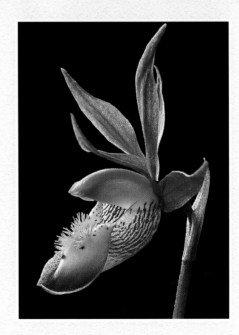

RIGHT Harebell (Gary Lackie)

FAR RIGHT Spider on fireweed (Calvin Hall)

BELOW RIGHT Calypso orchid (Gary Lackie)

BELOW Historic Kantishna miner's cabin
Denali National Park (Hugh Rose)

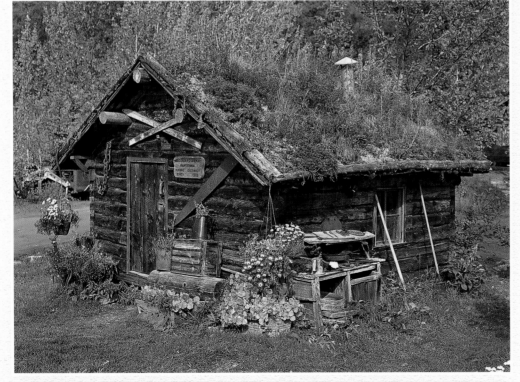

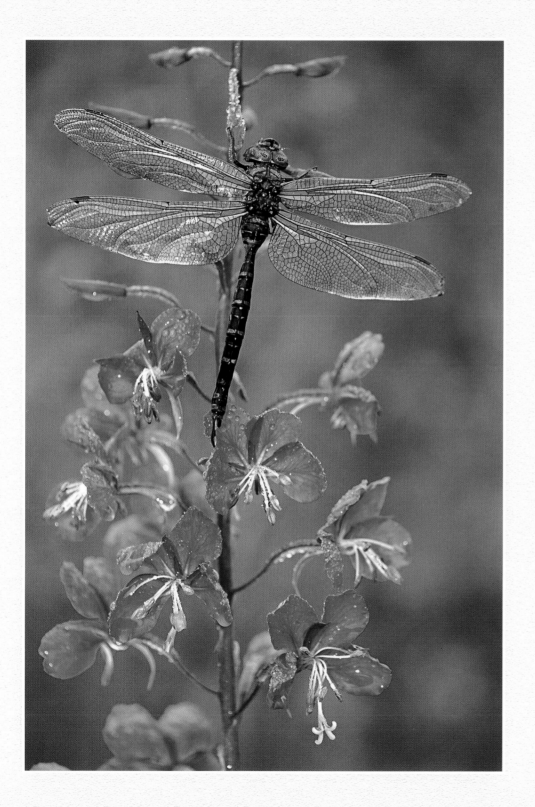

flowers

The Infinite has written
its name on the heavens
in shining stars
and on the earth
in tender flowers.

John Paul Richter

Dragonfly on fireweed
(Steven Nourse/Accent Alaska)

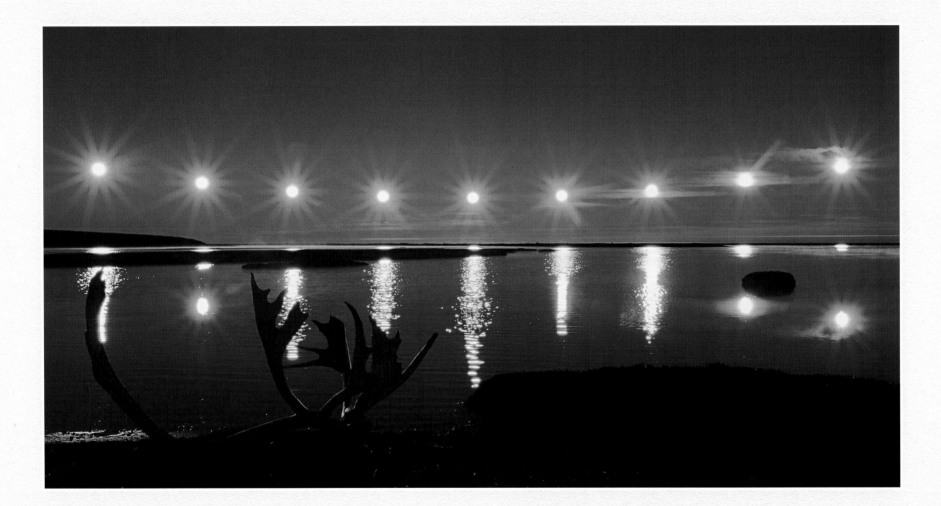

ABOVE Midnight sun at summer
solstice, Arctic National Wildlife
Refuge (Jo Overholt)

FACING PAGE Brown bear tracks along
shore of Naknek Lake, Katmai
National Park (Patrick Endres)

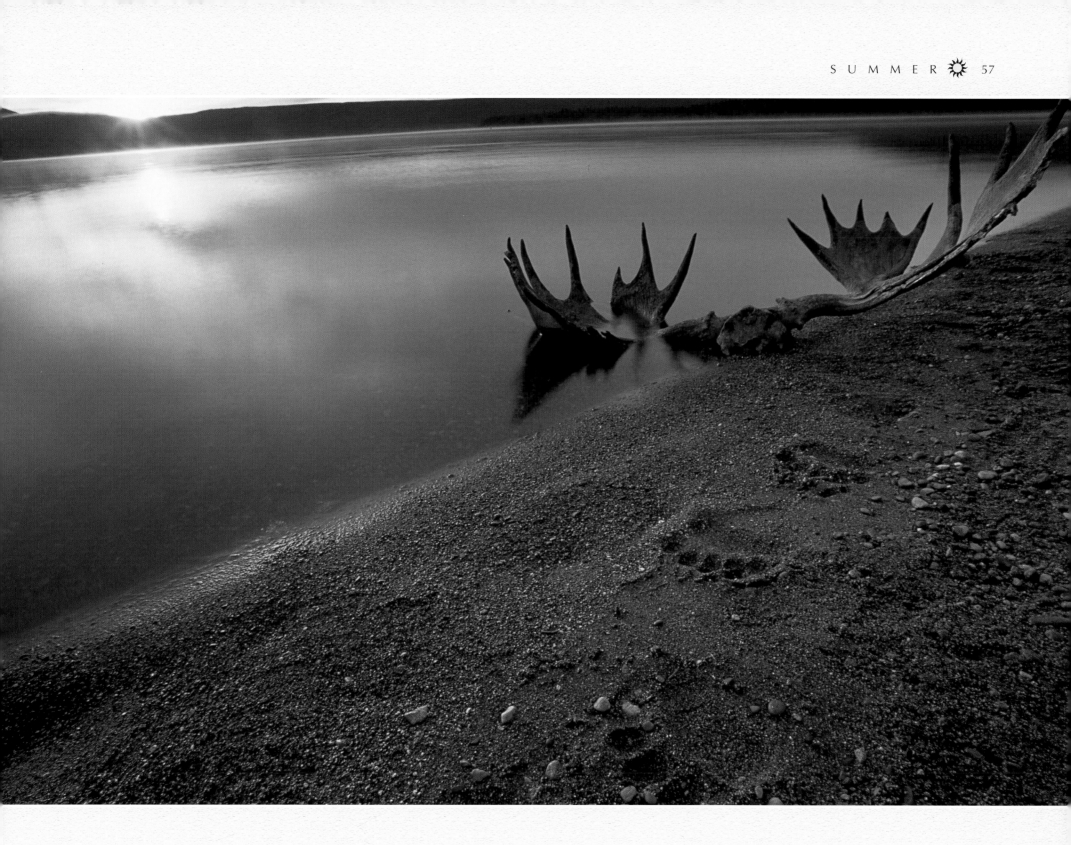

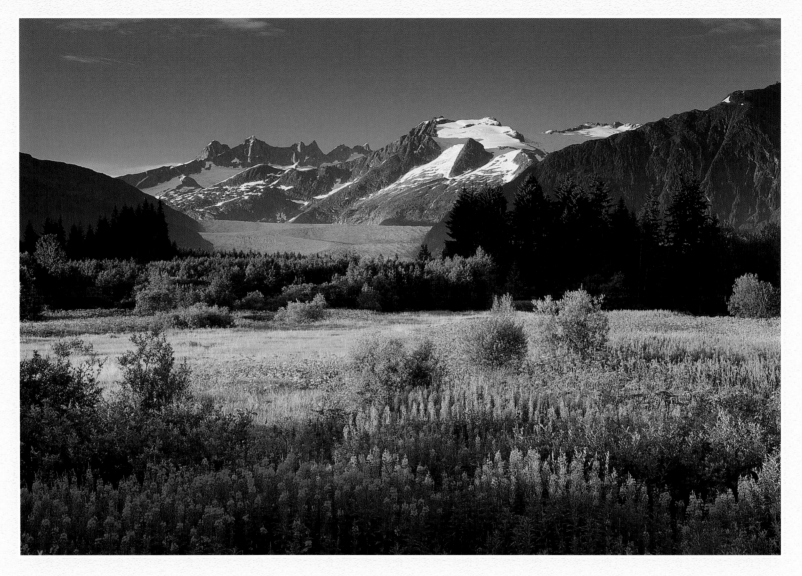

ABOVE Brotherhood Park and
Mendenhall Glacier, Juneau
(Kim Heacox)

FACING PAGE Sunset at Lake Kashwitna
Southcentral Alaska (Allen Prier)

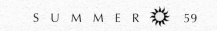

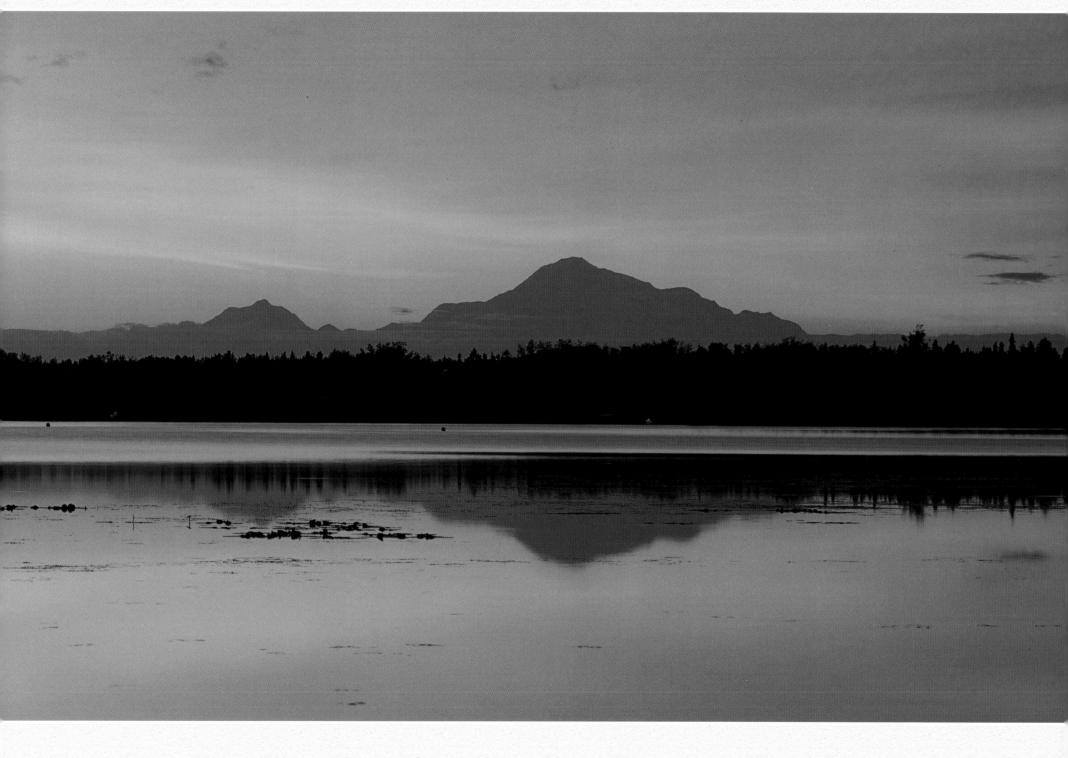

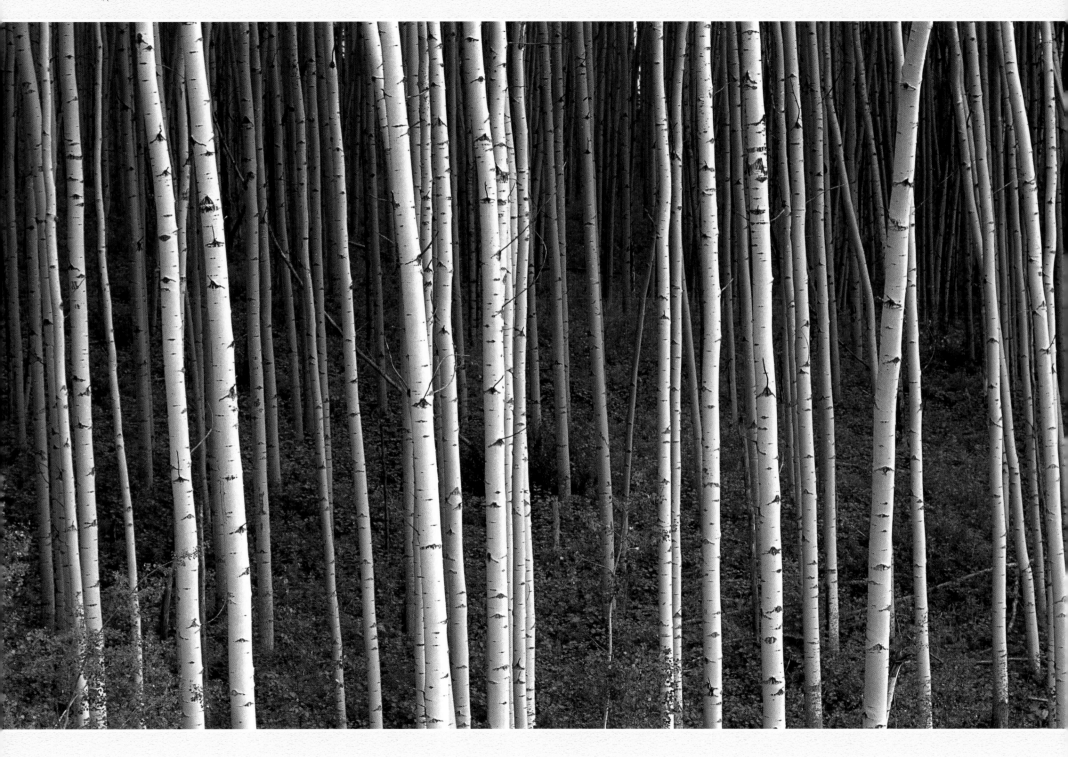

At times, in the pit of the encompassing silence, there is a sense of living and moving everywhere in the forest.

Richard Nelson
MAKE PRAYERS TO THE RAVEN

living

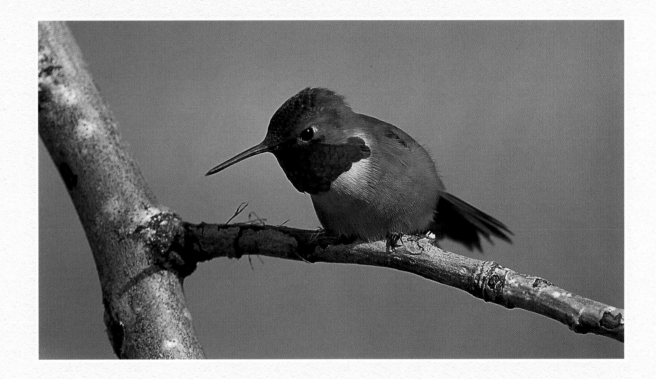

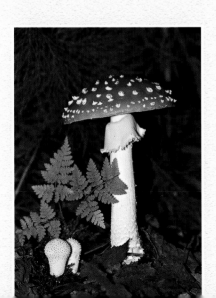

ABOVE Rufous hummingbird,
Anchorage (Calvin Hall)

LEFT Mushroom
(Gary Lackie)

FACING PAGE Aspen forest,
Southcentral Alaska
(John Warden/Alaska Stock)

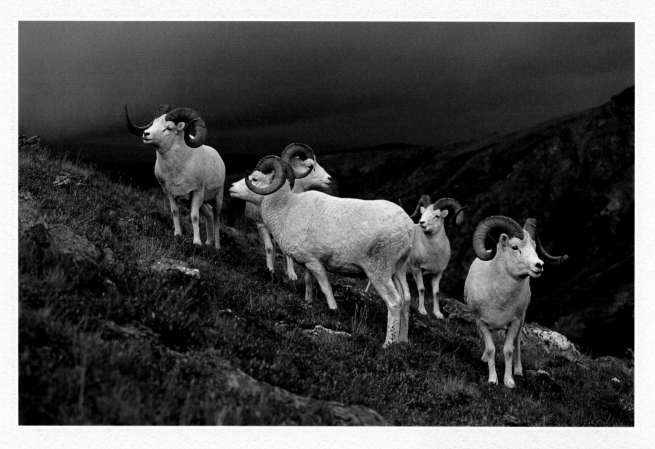

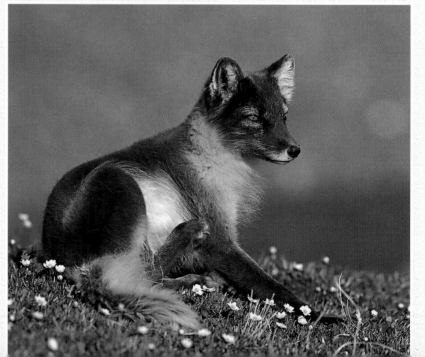

ABOVE Dall's sheep, Denali National Park
(Gary Lackie)

RIGHT Arctic fox, Arctic National
Wildlife Refuge (Jo Overholt)

FACING PAGE Moose in pond,
Denali National Park (Dorothy Keeler)

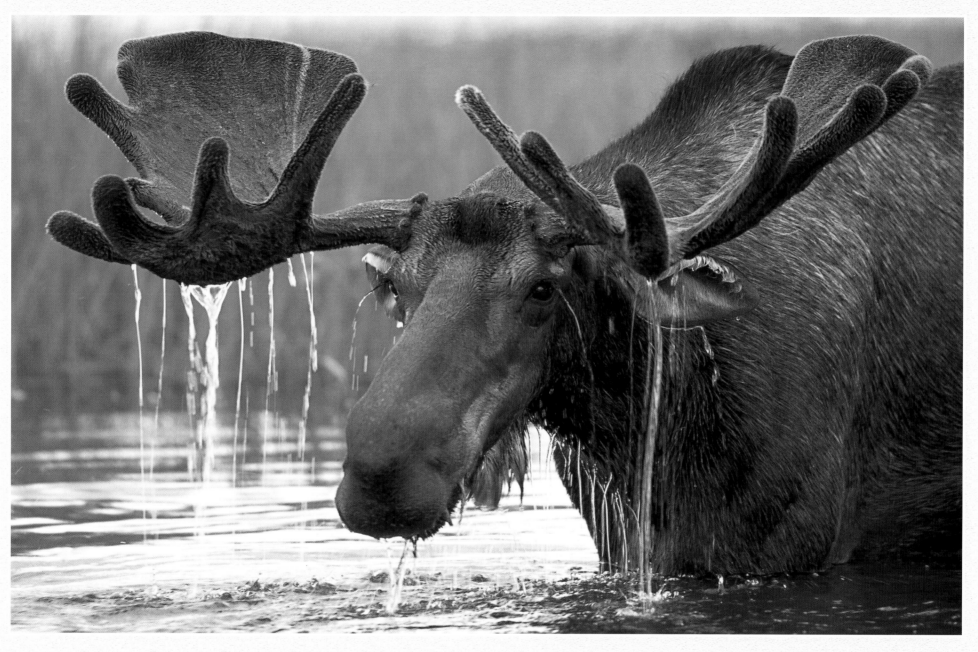

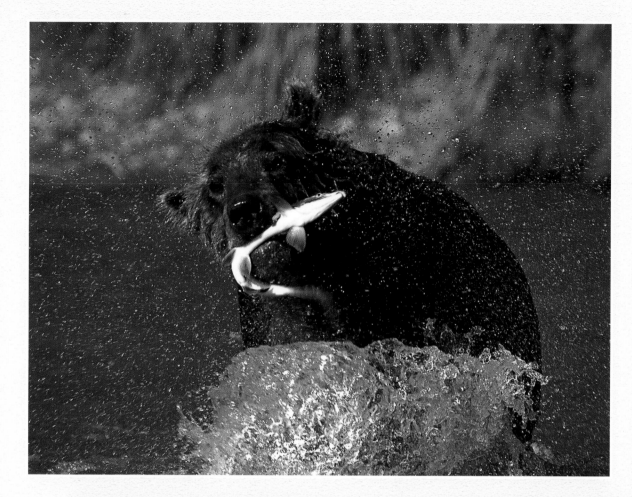

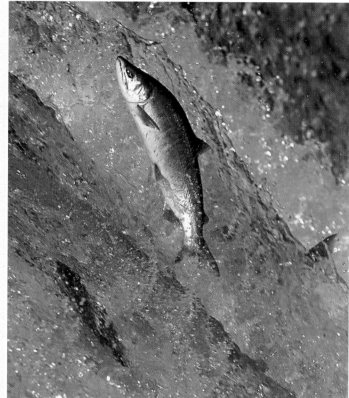

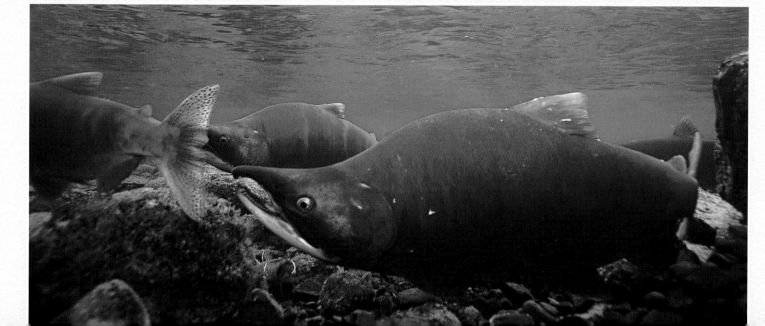

ABOVE LEFT Brown bear fishing,
Katmai National Park
(Steve Gilroy)

ABOVE RIGHT Spawning salmon,
Brooks River, Katmai National Park
(Greg Syverson)

LEFT Sockeye salmon,
Bristol Bay (Greg Syverson)

FACING PAGE Spawning salmon,
Bristol Bay (Greg Syverson)

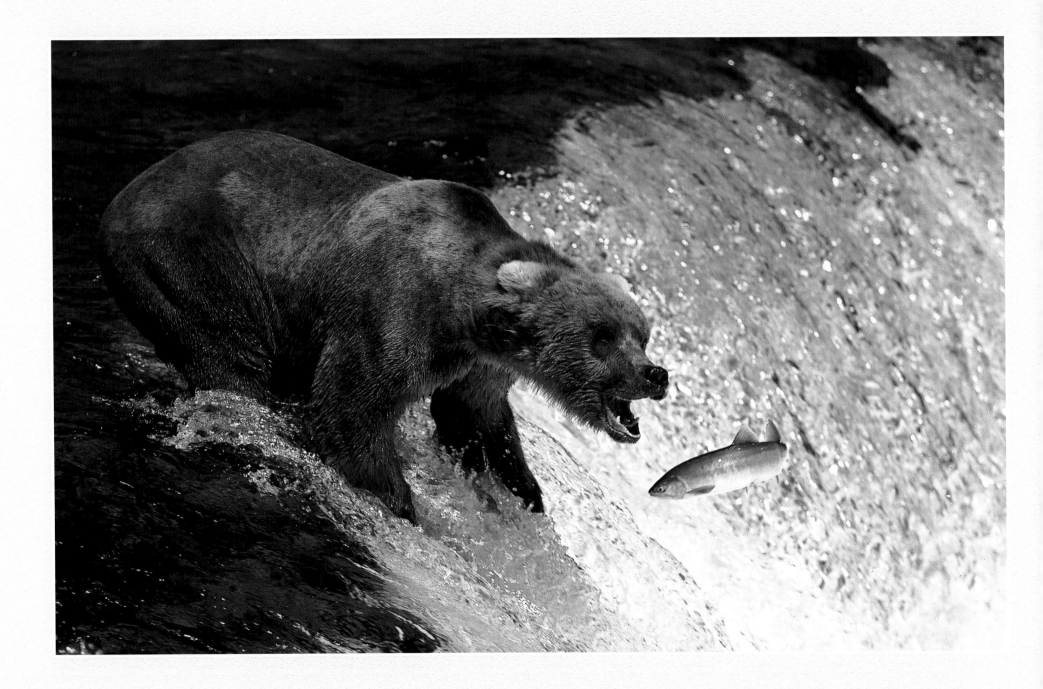

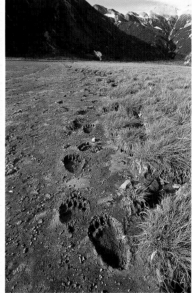

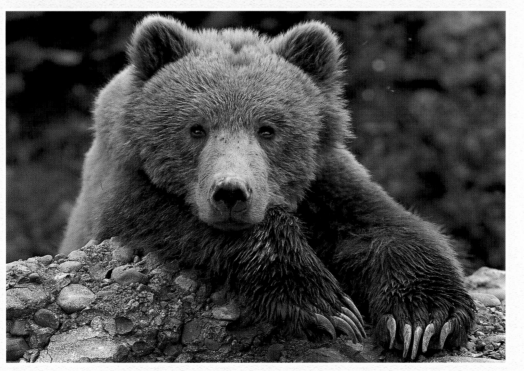

ABOVE LEFT Sleeping grizzly bear, Denali
National Park (Alissa Crandall)

ABOVE RIGHT Brown bear footprints,
Katmai Coast (Tom Bol)

LEFT Juvenile brown bear, McNeil River
State Game Sanctuary (Alissa Crandall)

FACING PAGE Brown bear fishing, Katmai
National Park (Gary Lackie)

Herbst

秋

Fall

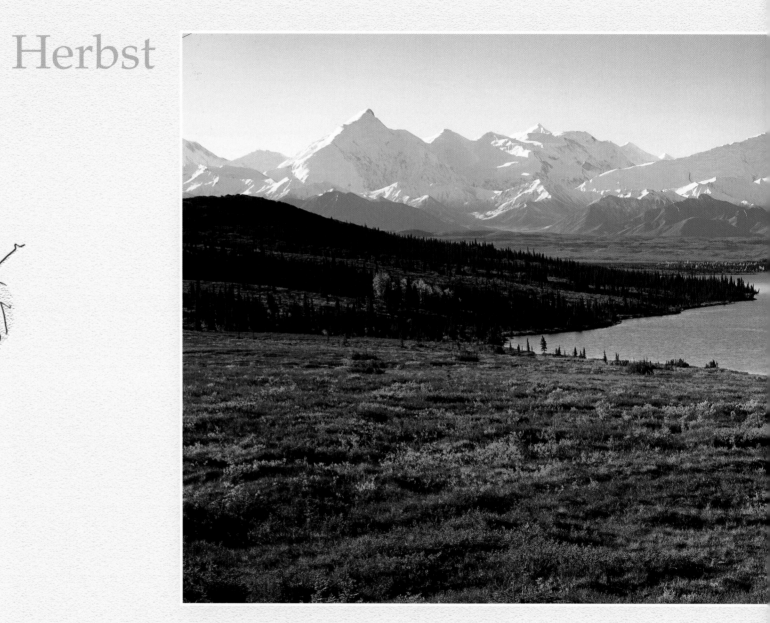

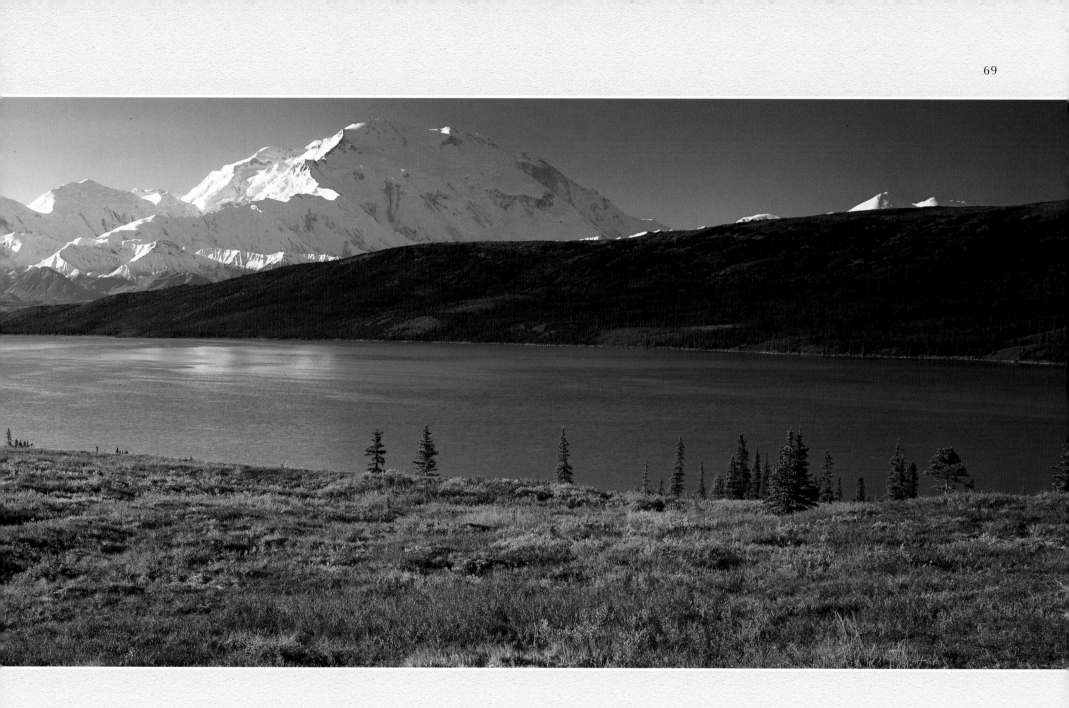

Wonder Lake and Mount McKinley,
Denali National Park (Allen Prier)

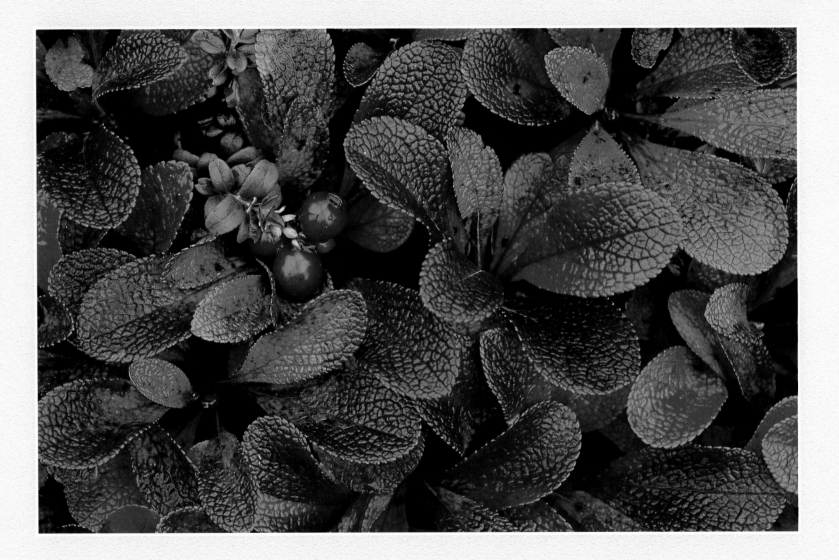

Fall

Suddenly it's fall. A chill bites the air. The days shrink, the nights grow. The tundra turns from green to rust and sienna and scarlet. This autumn palette happens in mid-August in the Brooks Range, late August in the Alaska Range, early September on the Kenai Peninsula. Birch and cottonwood trees turn yellow, yet the most dazzling autumn tree of all, the aspen, makes the others seem pale by comparison.

In Southeast Alaska, it's the rainy season. Ketchikan is one of the wettest places, receiving more than 11 feet of rainwater annually. In the state capitol of Juneau, legislators wear rubber boots and broad-rimmed hats, not unlike local fisherman.

The first new snow of the season, what Alaskans call "termination dust," frosts mountain shoulders like powered sugar and reminds everyone that Old Man Winter is just around the corner. Waves of birds depart for warmer climes while a small number of year-round residents—ptarmigan, raven, gyrfalcon, black-billed magpie, boreal chickadee—fluff their feathers against the coming cold. Hibernating rodents disappear, but large male ungulates—bull moose, bull caribou, Dall's sheep rams—battle on their rutting grounds to determine mating dominance. Soon they will settle down to the business of survival.

So it is that autumn, the shortest of the Alaska seasons, doesn't last long against winter's impatience. Soon another year has come and gone and people ask: where did the time go? It went to Alaska, to seasons and adventures and living in the north—the best investment a free spirit can make.

FACING PAGE Low-bush cranberry on tundra
(Cliff Riedinger/Alaska Stock)

秋

突然に秋がやってくる。寒さが空気を噛む。日が見る見る間に短くなり、夜が長くなる。ツンドラが緑から、赤、ゴールドまでの様々の色に変わる。こうしたことはブロックス山脈では8月の中ごろから、アラスカ山脈では8月末、キーナイ半島では9月初めに始まる。バーチとコットンの木が黄色に変わる。ポプラが最も明るい色をみせる。南東部のアラスカでは、この時期は雨期だ。ケチキャンは最も雨の多い場所のひとつで、年に3メートル以上の雨が降る。

アラスカンが「ターミネーション　ダスト」と呼ぶ、シーズン最初の雪が山の頂上を覆うと、人々に冬がもう近いことを思わせる。数少ない鳥たちが寒い気候に慣れて留まる中、多くのグループの鳥達が群れをなして暖かい気候を求めて旅立ってゆく。囓歯類の動物は冬眠する。大きな有蹄類動物の雄たち、ムース、トナカイ、ドールシープたちは一番強いものを決めるために戦う。彼等もすぐに冬を生き延びる為に落ち着き始める。

これが、秋、冬の気短さに負け、長く続くことのないアラスカの最も短い季節だ。すぐにまた新しい年がやってきては過ぎ、人々はたずねる。時はどこへいってしまったの？時は行った。アラスカへ、四季へ、アドベンチャー、そして、北での生活へ。

Frost on dwarf birch
leaf (Calvin Hall)

Herbst

Plötzlich und unerwartet ist der Herbst da. Die Luft ist beißend kalt geworden. Die Tage sind merklich kürzer. Die grüne Tundra verfärbt sich und erscheint in vielen Rot- und Goldtönen. In der Brookskette erscheint die Herbstfärbung Mitte August, in der Alaskakette Ende August und auf der Kenai-Halbinsel Anfang September. Das Birken- und Pappelnlaub verfärbt sich gelb. Das Espenlaub zeigt sich im leuchtendsten Gelb. In Südost Alaska ist dies die Regensaison. In Ketchikan, dem regenreichsten Ort, werden jährlich 3 Meter Regenfall gemessen.

Der erste Schnee fällt - in Alaska wird er "Termination Dust" genannt - und bedeckt die Bergspitzen. Er kündigt den bevorstehenden Winter an. Die Vögel verlassen Alaska in Scharen und fliegen in wärmere Gegenden. Einer kleinen Anzahl gelingt es, sich an die Kälte anzupassen und zu überwintern. Die Nagetiere fallen in den Winterschlaf. Große, widerkäuende Elchbullen, Cariboubullen und Dall-Schafböcke messen ihre Stärke im Kampf. Bald lassen sie sich für den Winter nieder.

So kommt es, daß der Herbst, die kürzeste Jahreszeit, der Ungeduld des Winters nicht lange widerstehen kann. Bald ist wieder ein Jahr vergangen und die Menschen fragen sich: "Wo ist die Zeit nur hingegangen?" Alaska, die Jahreszeiten, das Abenteuern und das Leben im Norden haben sie verzehrt.

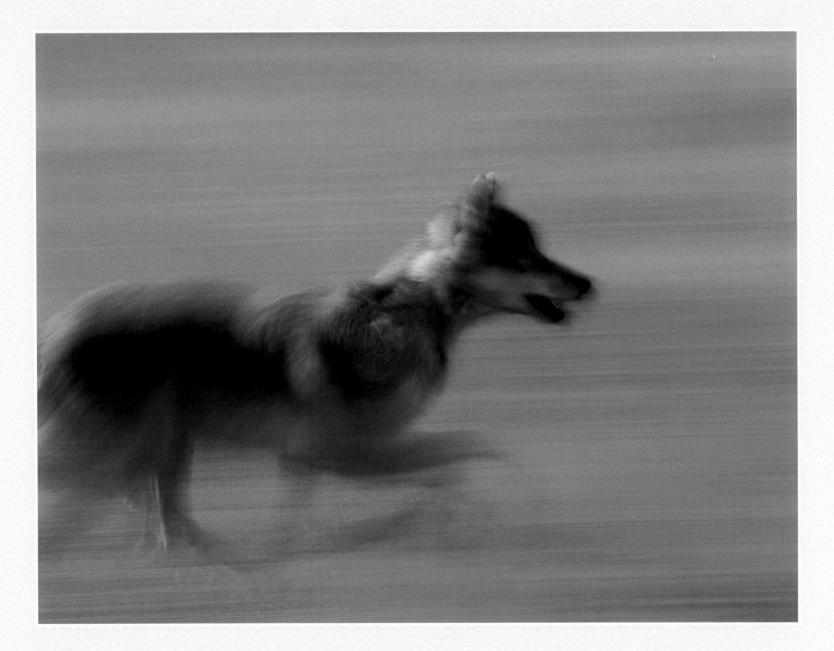

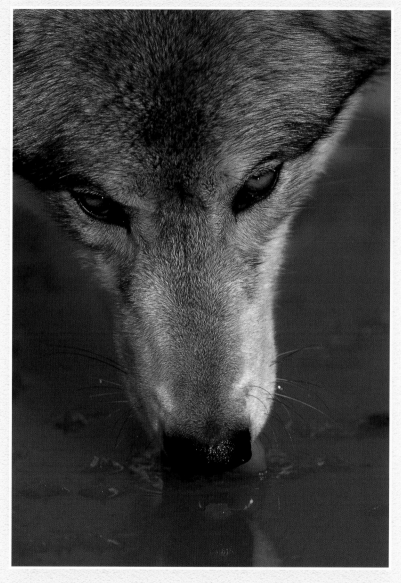

To the lover of pure wildness,
Alaska is one of the most wonderful
countries in the world..

John Milton

wildness

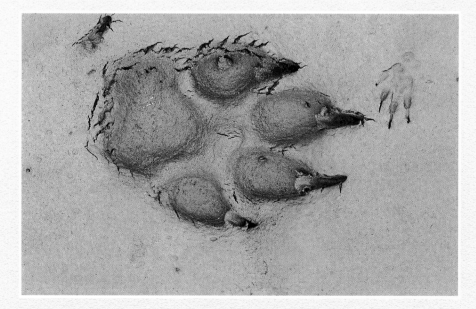

ABOVE Gray wolf (Lon Lauber)

LEFT Tracks of gray wolf and Arctic ground
squirrel, Noatak River (Michael DeYoung)

FACING PAGE Wolf in motion
(Jennifer Fogle)

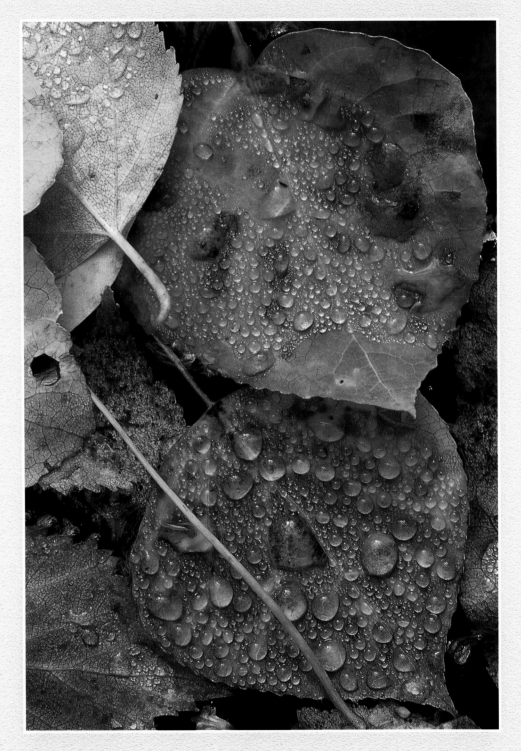

The clearest way into the wilderness
is through a forest wilderness.

John Muir

the forest

LEFT Aspen leaves, Hatcher Pass
(Tom Bol)

FACING PAGE Aspen trees, Fairbanks
(Greg Syverson)

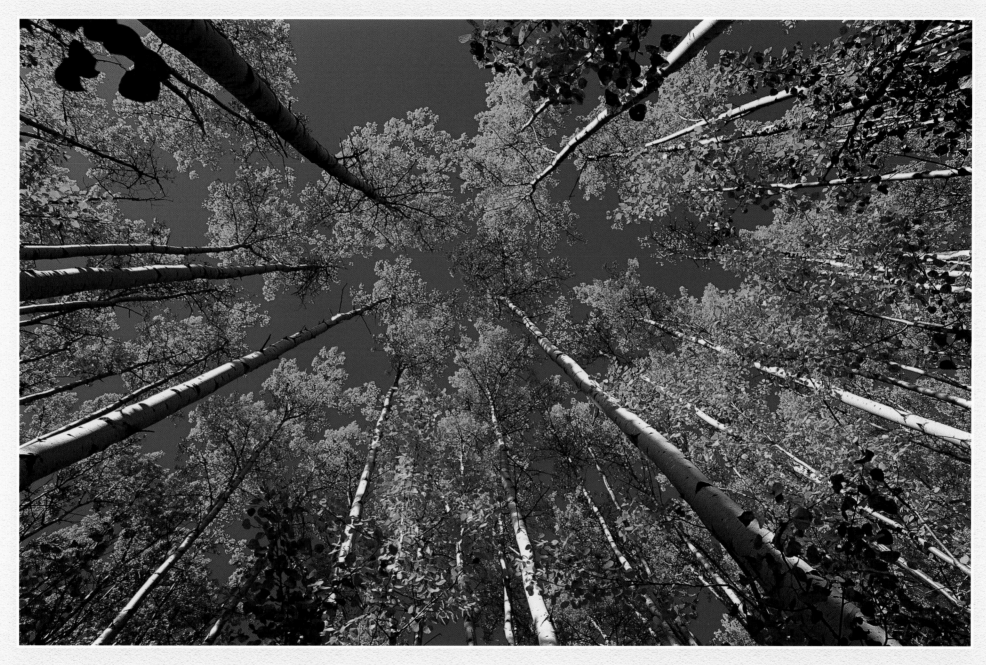

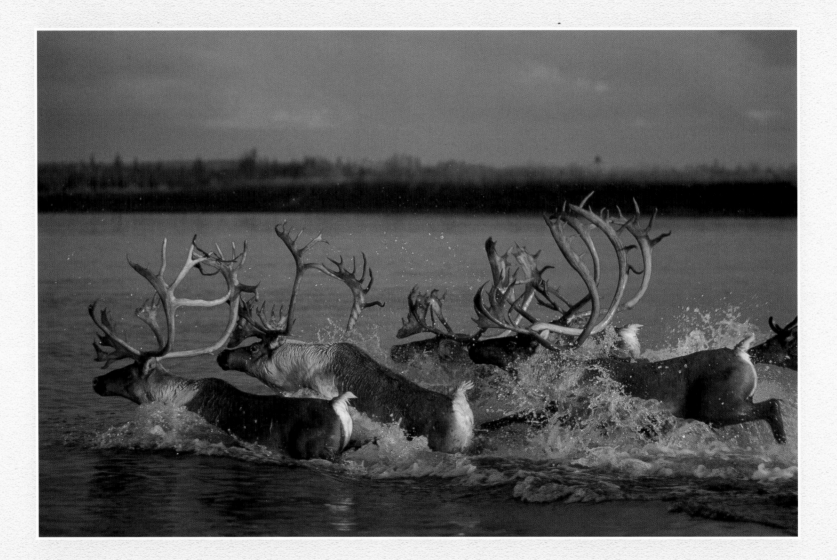

ABOVE Caribou crossing Kobuk River
(Nick Jans/Alaska Stock)

FACING PAGE Mount McKinley and caribou,
Denali National Park (composite image by
Kim Heacox and M. Nieman/Accent Alaska)

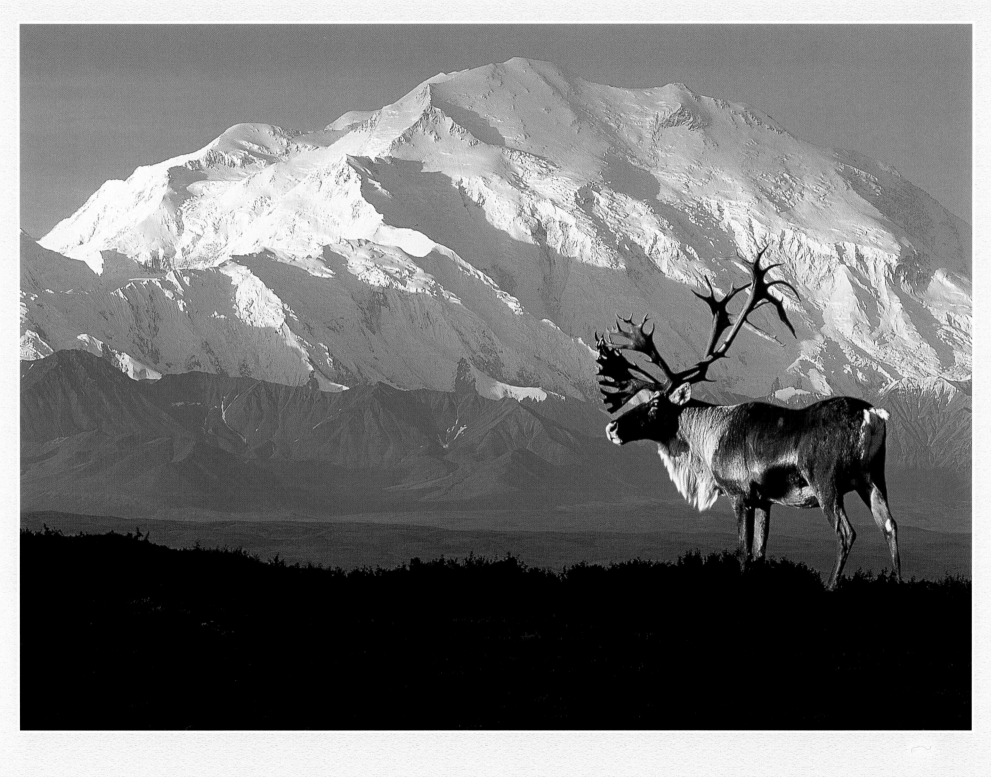

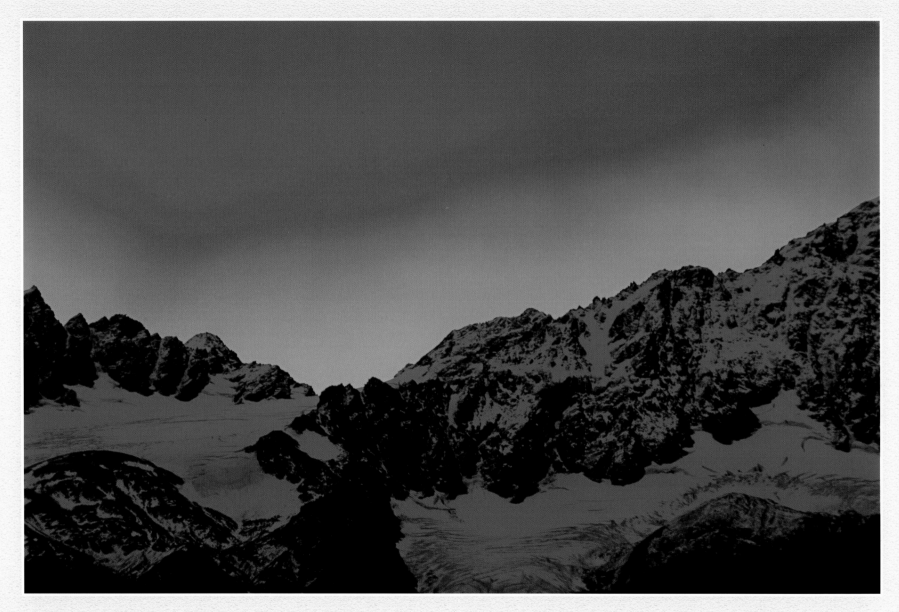

ABOVE Sunrise over Chugach Mountains,
Seward (Ron Niebrugge)

FACING PAGE Ptarmigan in transition plumage,
Arctic National Wildlife Refuge (Hugh Rose)

I never watch a sunset without feeling
the scene before me is more beautiful
than any painting could possibly be,
for it has the additional advantage
of constant change, and is never the
same from one instant to the next.

Sigurd F. Olson
REFLECTIONS FROM THE
NORTH COUNTRY

sunsets

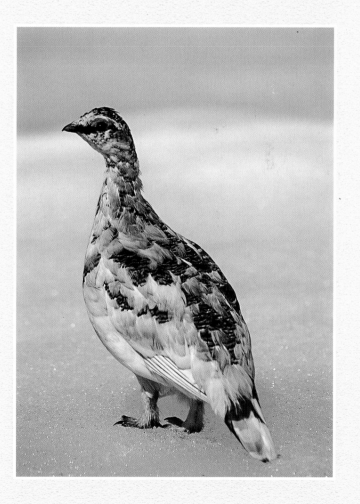

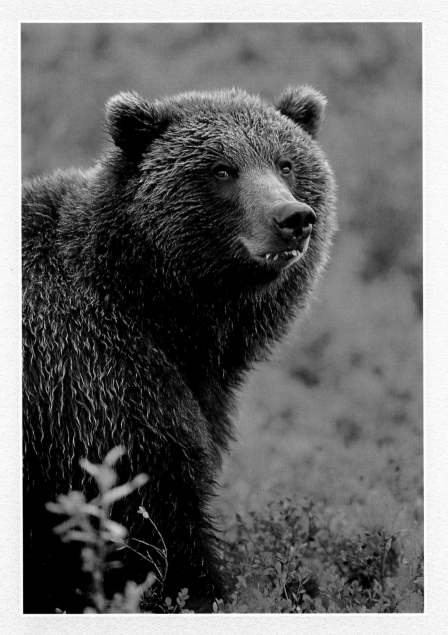

nature

Nature is the art of God.

Dante

ABOVE Grizzly bear in tundra,
Denali National Park (Patrick Endres)

FACING PAGE Grizzly bear crossing ridge at sunset,
Denali National Park
(composite image by Pat Warwick/Alaska Stock)

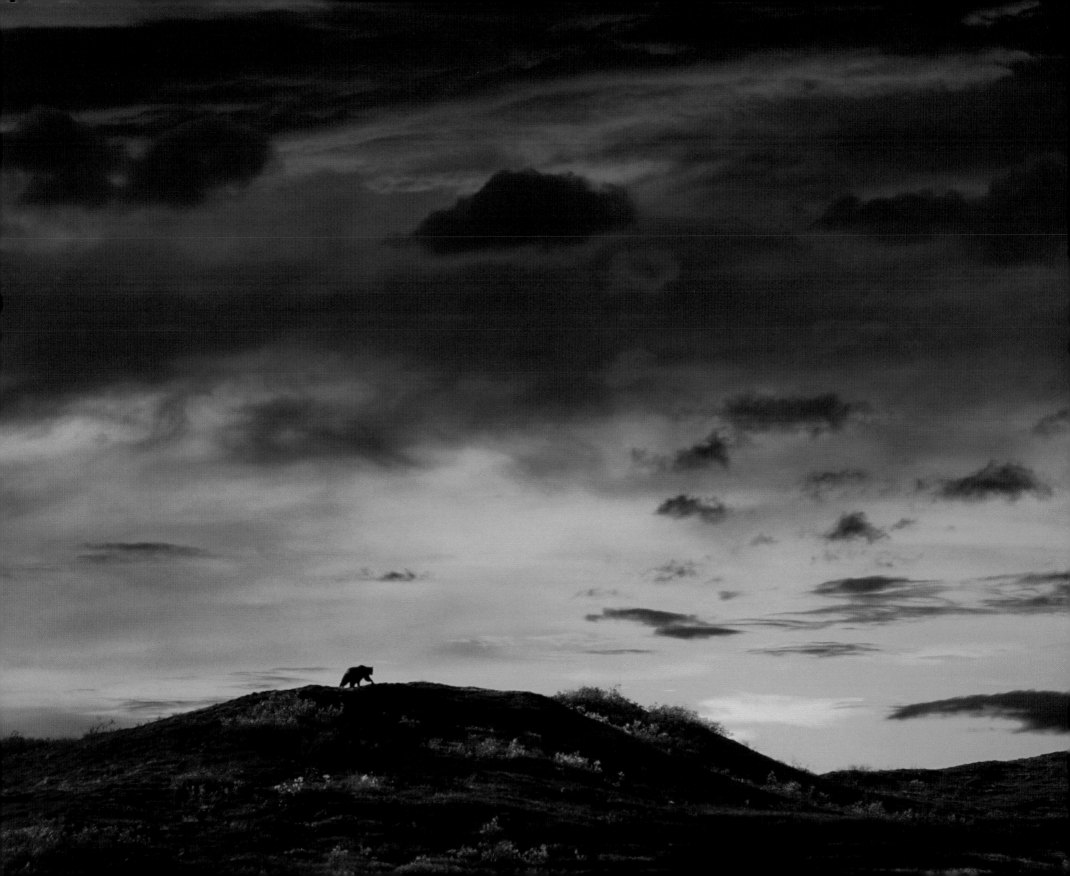

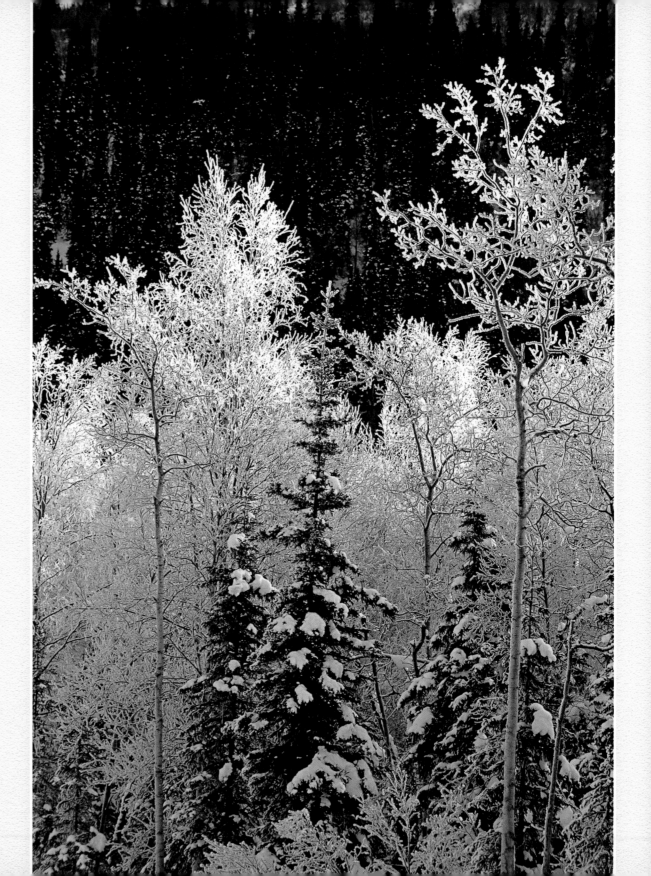

RIGHT Rime ice on birch trees
(Michael DeYoung/Alaska Stock)

FACING PAGE Aspen leaf on fern
Talkeetna (Jon Nickles)

There are from time to time, mornings,
both in summer and winter,
when the world has been visibly
recreated in the night.
Mornings of creation I call them.

mornings

Henry Thoreau
WALDEN

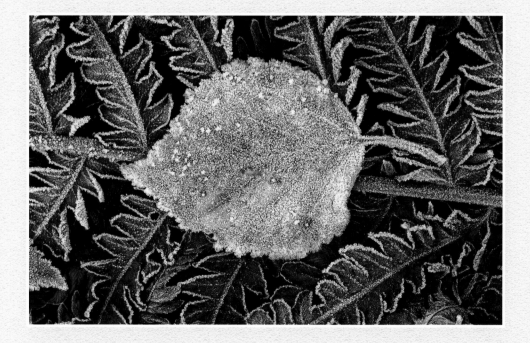

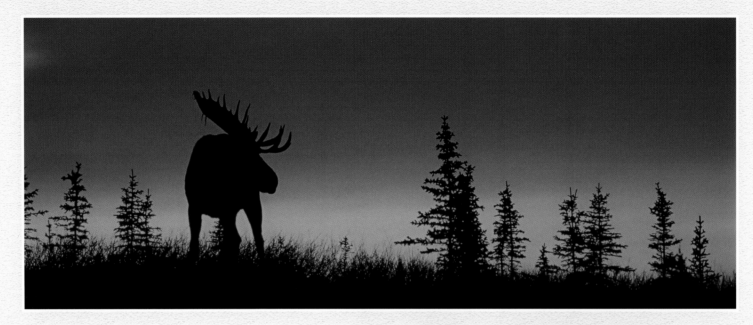

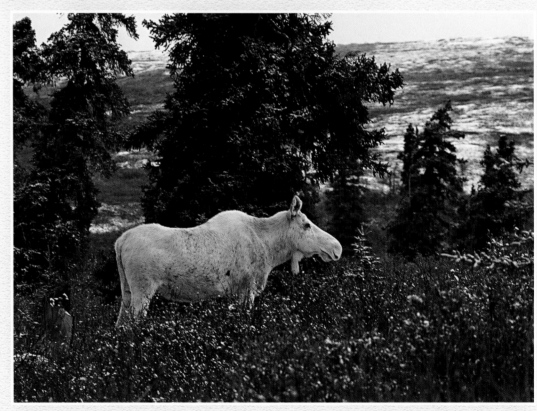

ABOVE Moose at sunset, Denali National Park (Tony Dawson)

RIGHT White moose, Denali National Park (Vic VanBallenberghe)

FACING PAGE Moose running through Wonder Lake, Denali National Park (Alissa Crandall)

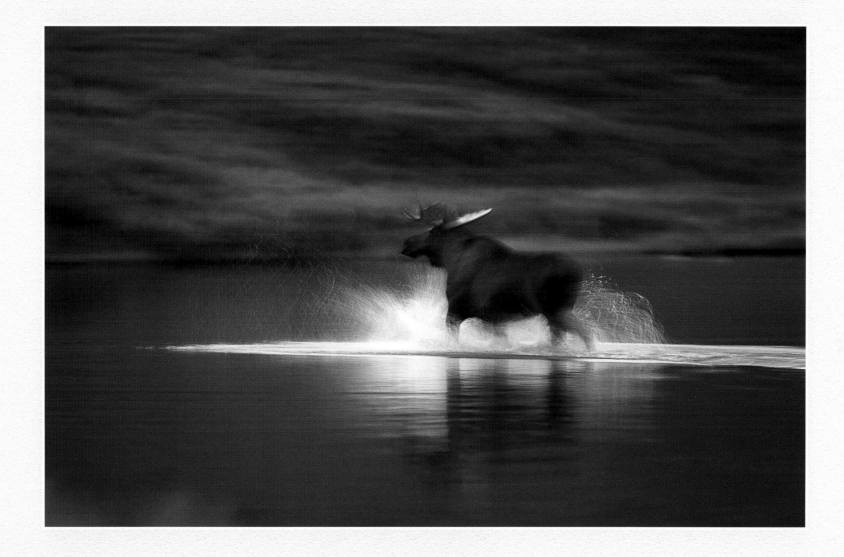

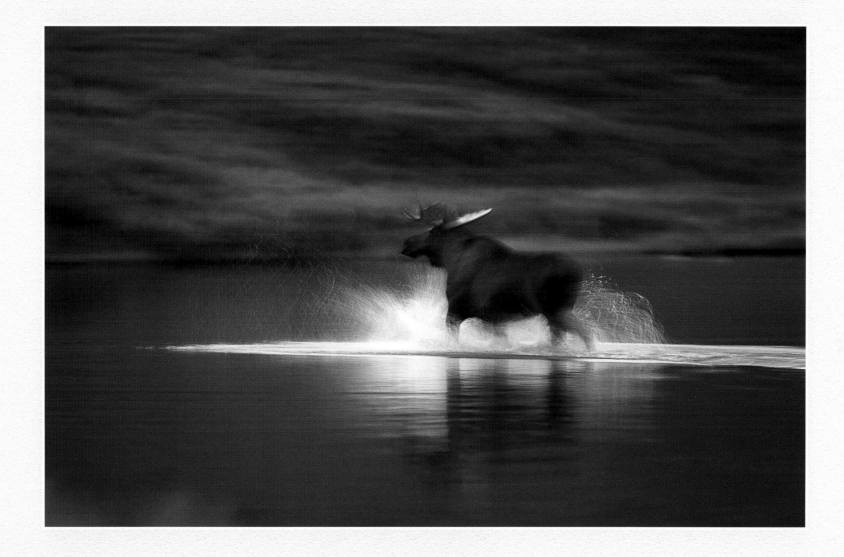

simplicity

But it is very important to us
to seek out undisturbed
quiet segments
of our environment in order to feel
the incredible simplicity
and wonderment of earth.

David Cooper

RIGHT Autumn leaves in ice, Eagle River
(Vance Gese)

FACING PAGE First snow of the season,
Denali National Park (Vance Gese)

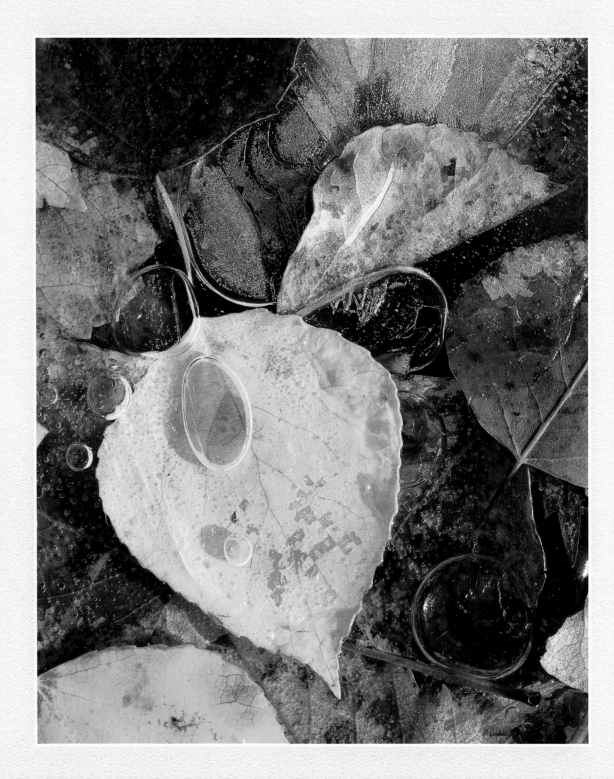

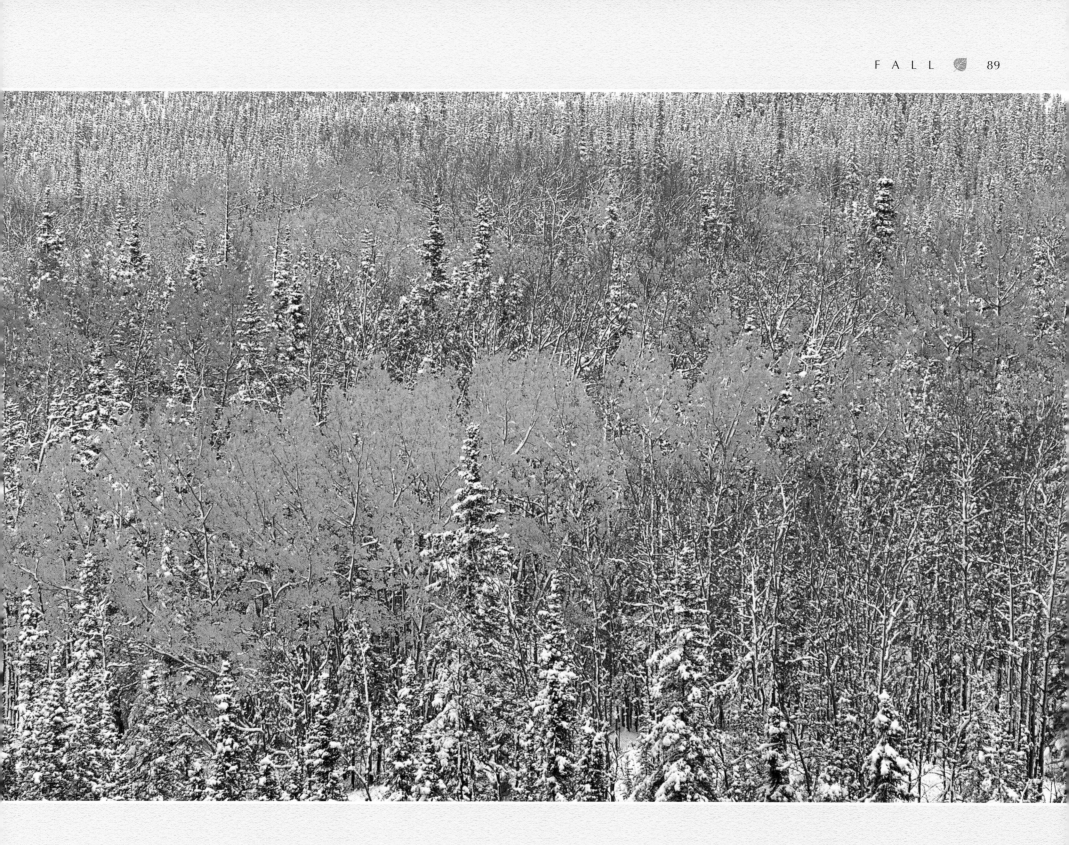

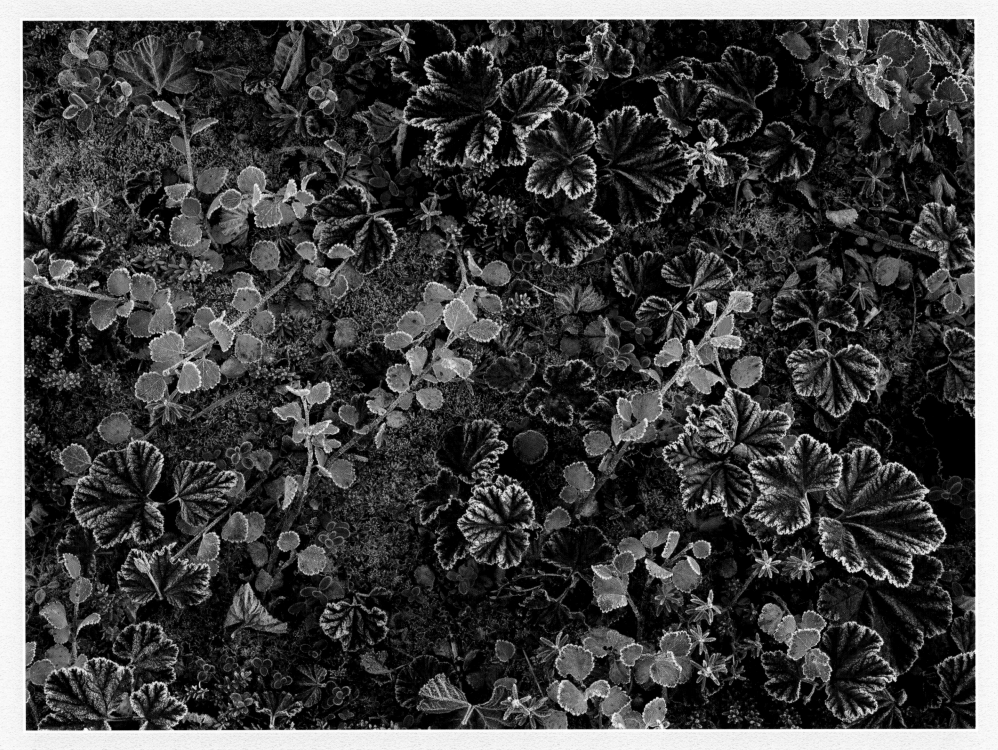

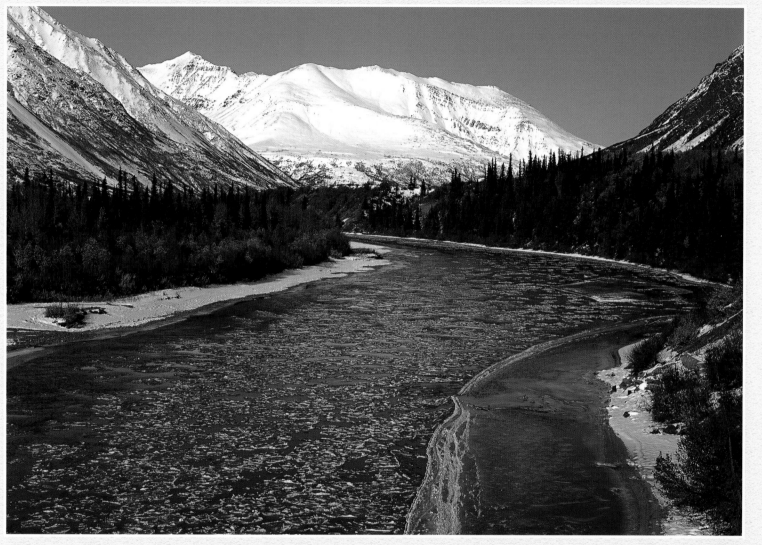

LEFT Ice forming in the Nenana River
(Tony Dawson)

RIGHT Cottonwood leaf imbedded in ice,
Ship Creek, Anchorage (Jon Nickles)

FACING PAGE Fall colors on tundra plants,
Alaska Range (Bruce Herman)

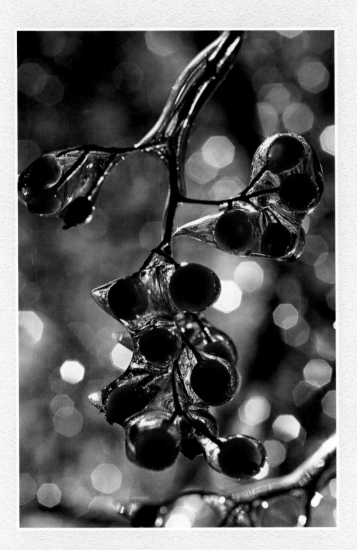

But it is not only the outward beauty
of Alaska that we must think about
when considering its future;
we must also think of its native wildness—
its wilderness spirit.
This we cannot improve.

Adolph Murie
A NATURALIST IN ALASKA

spirit

ABOVE Ice-coated berries
(George Herben/Alaska Stock)

FACING PAGE Brown bear sow and cub
retiring for the winter, Katmai National Park
(Johnny Johnson/Alaska Stock)

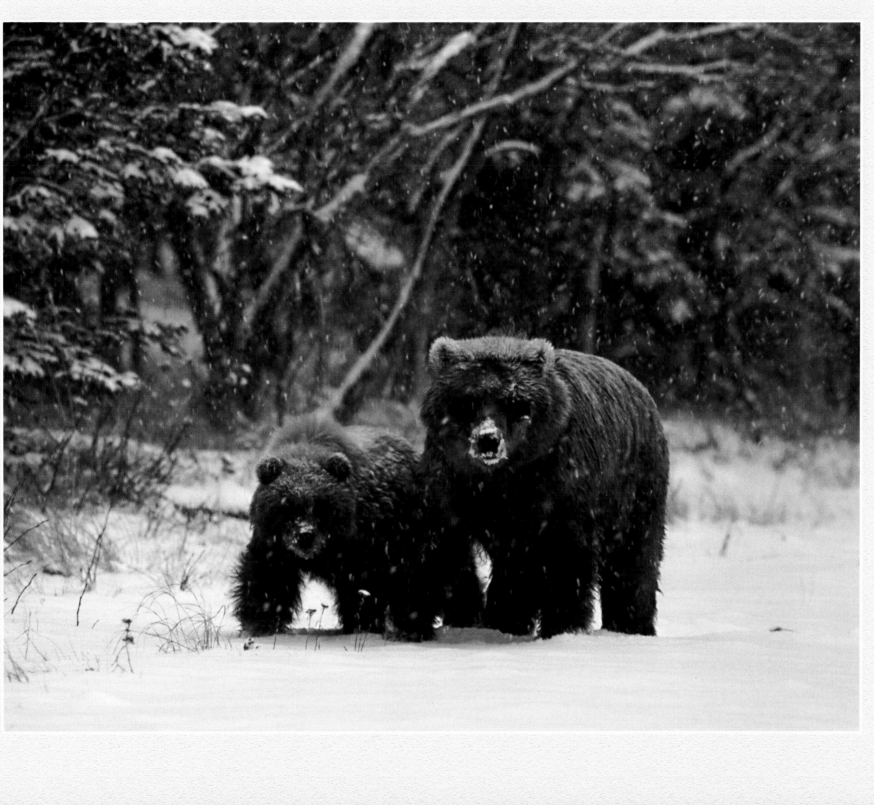

冬
Winter

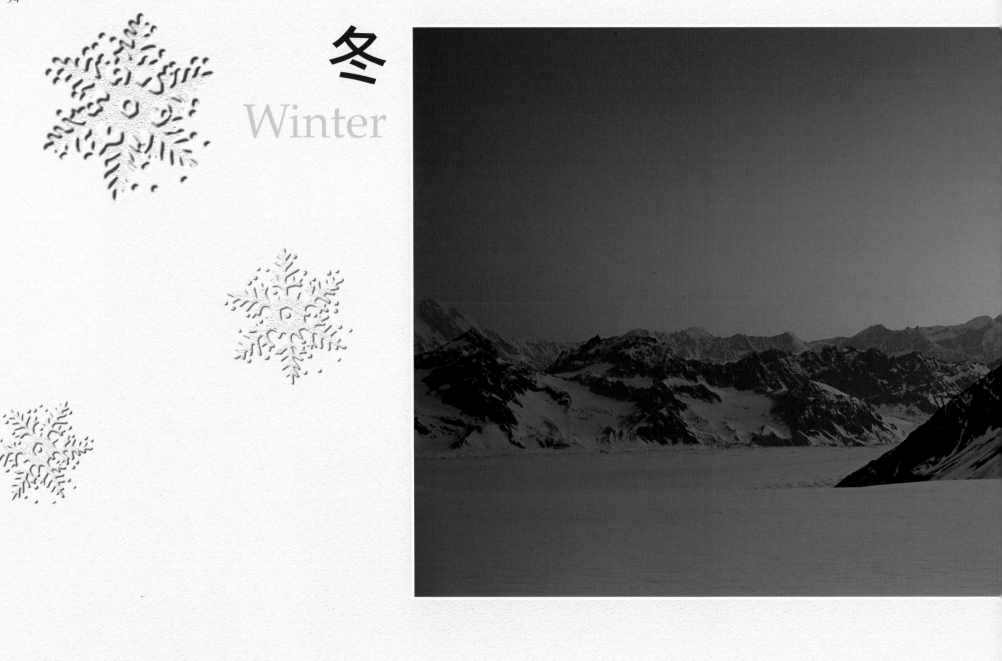

Winter

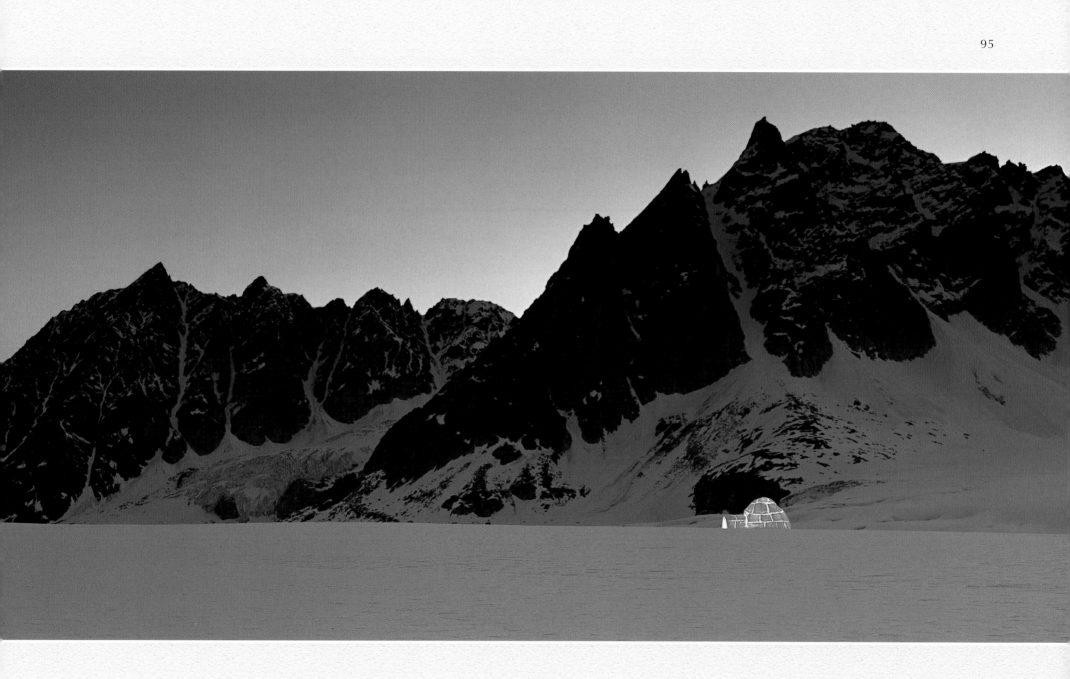

Ruth Amphitheater, Mount McKinley,
Denali National Park
(Michael DeYoung/Alaska Stock)

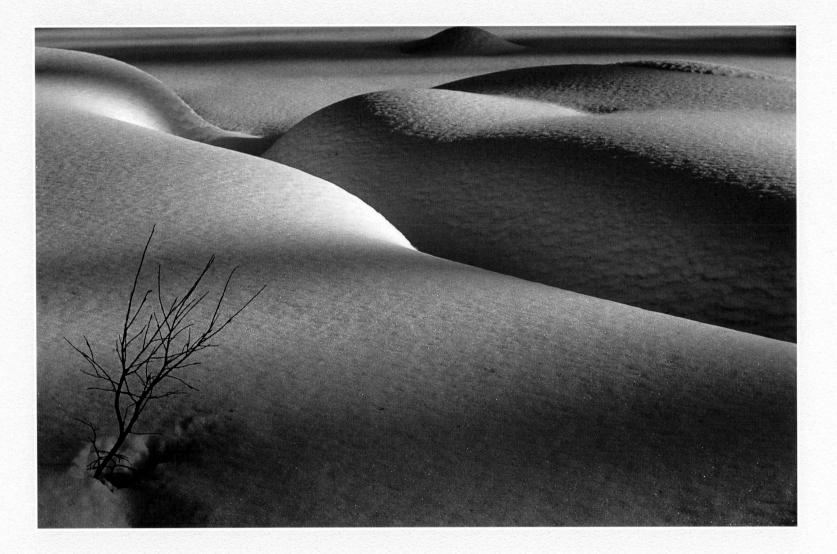

Winter

Winter is the marathon. Every other season is in response to—and preparation for—winter. In Barrow, at 71 degrees latitude the northernmost settlement in Alaska, the sun sets on November 19 and doesn't rise again until January 23. Residents call it "The Tunnel," that long, cold ride through a netherworld darkness. Thermometers drop to minus 40 (the same temperature on both Fahrenheight and Celsius scales) and stay there for weeks. Wind chills knock it down another 20, 30, or 40 degrees. Exposed skin freezes in minutes. Cars and trucks idle around the clock. In Fairbanks, Alaska's second largest city (after Anchorage), ice fog grips the streets and decorates the trees with a fantasia hoarfrost.

Yet this coldest, darkest of seasons brings the whitest of gifts—snow. Eskimos have more than two dozen words for snow. For them, snow is an open book where upon they can read the tracks of polar bear and arctic fox, the shapes of drifts, the textures of crust, the stories of the land.

Snowfall at Thompson Pass north of Valdez often exceeds 25 feet per season. One winter Valdez residents found snow reaching the second floor windows of their homes.

The other great gift of winter is the aurora borealis, when tendrils of northern lights dance in greens, whites and reds across star-filled skies.

Winter does not lock Alaska, it opens it. As days lengthen in March, dog mushers and cross-country skiers travel over white wonderlands and frozen rivers to reach their favorite cabins where they can sit around a crackling stove fire and tell stories that express the same thing—a deep love for open space, for immense silence, and for the gift of winter in Alaska.

FACING PAGE Aspen and snowbanks, Judd Lake
(Shelley Schneider)

冬

冬は、マラソンのごとくに一番長い季節だ。他のそれぞれの季節は、冬に呼応としての、また準備としての季節である。バローでは、（北緯７１度に位置するアラスカでの最北の居住地）１１月１９日に日が沈み、１月２３日まで昇ってこない。そこに住む人たちは、それを長い暗闇の旅にちなんで「トンネル」と呼んでいる。気温は、マイナス４０度（華氏でも摂氏でも同じ）まで落ち込み、その状態が何週間にも渡って続く。　むき出しの皮膚は数分で凍る。車、トラックは常にエンジンをかけたままになっている。アラスカ第二の都市、フェアバンクス（アンカレッジに継ぐ）では、凍った霧が空気を雲のようにみせ、また氷結が木々を飾る。

この最も寒く、暗い季節が純白のギフト一雪をもたらす。エスキモーたちは、２４の「雪」という言葉をもっている。彼等にとって雪は開かれた本であり、そこにかれらは、しろくまや、北極きつねの足跡を見つけ、雪風の流れる向き、地殻の表情、そして大地の物語りを読むことができる。

バルディーズの北、トンプソンパスでの積雪量は、ひと冬に7メートルを超す。ある冬には、バルディーズの住人たちは、雪が2階の窓まで届いているのを見たこともある。

冬のほかの素晴らしいギフトは、満点の星空に緑、白、赤のオーロラが舞うことだ。

冬はアラスカの人々を閉じ込めず、解放する。３月になり、日照が長くなるにつれ、犬ぞり引きたちや、クロスカントリースキーヤーたちが、お気に入りのキャビンへと、白い原野、凍った川をはしりぬけ、暖かく燃える火の周りにすわり、広々とした土地やすみとおった静けさ、そしてアラスカの冬がもたらすギフトへの限り無い思いを語るのだ。

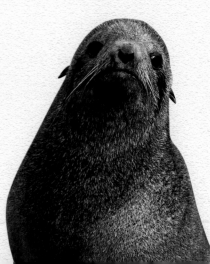

Winter

Winter, mit einem Marathon vergleichbar, ist die längste Jahreszeit. Die anderen sind entweder Folge—und Vorbereitung—auf den Winter. In Barrow (am 71. Längengrad und damit die nördlichste Ansiedlung Alaskas) verschwindet die Sonne am 19. November hinter dem Horizont und erscheint erst am 23. Januar wieder. Die Bewohner nennen diese lange, kalte Reise durch die Dunkelheit den "Tunnel". Die Temperatur fällt bis - 40 Grad (bei der Celius- und Fahrenheitwert gleich sind) , wo sie wochenlang verweilt. Bei dieser Temperatur friert ungeschützte Haut in Minuten. Die Fahrzeugmotoren werden nie ausgeschaltet. In Fairbanks, der zweitgrößten Stadt Alaskas (nach Anchorage), läßt Eisnebel die Luft wie eine Wolke erscheinen und bedeckt die Bäume mit einem Frostmantel.

Die kälteste, dunkelste Jahreszeit bringt aber auch das weißeste Geschenk - den Schnee. In der Eskimosprache gibt es 21 Wörter für Schnee. Für sie ist der Schnee wie ein offenes Buch, das die Spuren der Eisbären, der Polarfüchse, die Form der Schneewehen, die Struktur der Schneekruste und die Legenden offenbart.Im Thompson Paß nördlich von Valdez fällt oft mehr als 7 Meter Schnee pro Saison. Einmal türmte sich der Schnee bis zum ersten Stock der Häuser.

Das andere wunderbare Geschenk des Winters ist das Nordlicht, das in grünen, weißen und roten Farben am Sternenhimmel seinen Tanz vollführt.

Der Winter schließt Alaska nicht ein, im Gegenteil, er öffnet das Land. Wenn im März die Tage länger werden, begeben sich Schlittenhundeführer und Skilangläufer über zugefrorenen Flüßen und durch die weiße Landschaft auf den Weg zu ihren liebsten Hütten. Am knisternden Ofenfeuer sitzen sie zusammen und erzählen von der Liebe, die sie für die weiten Landflächen, die tiefe Stille und das Geschenk des alaskanischen Winters empfinden.

Fur seal, Pribilof Islands
(Edward Bovy)

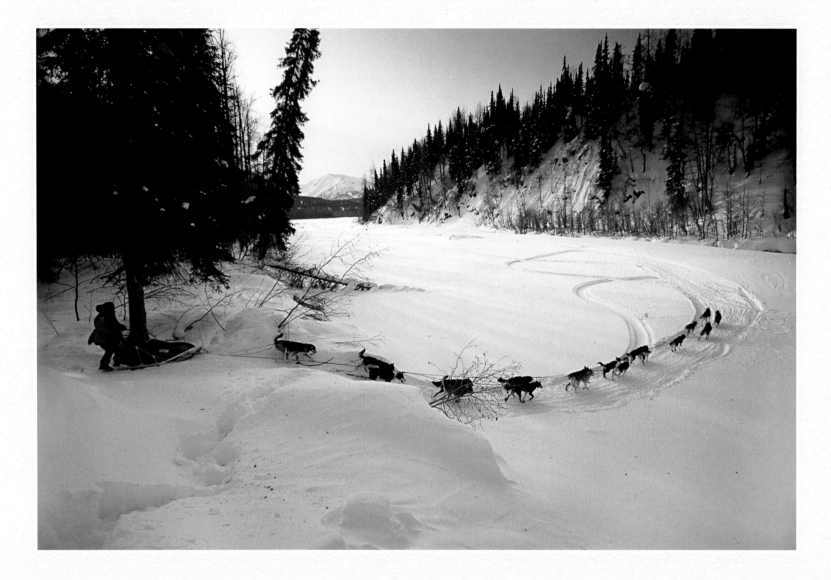

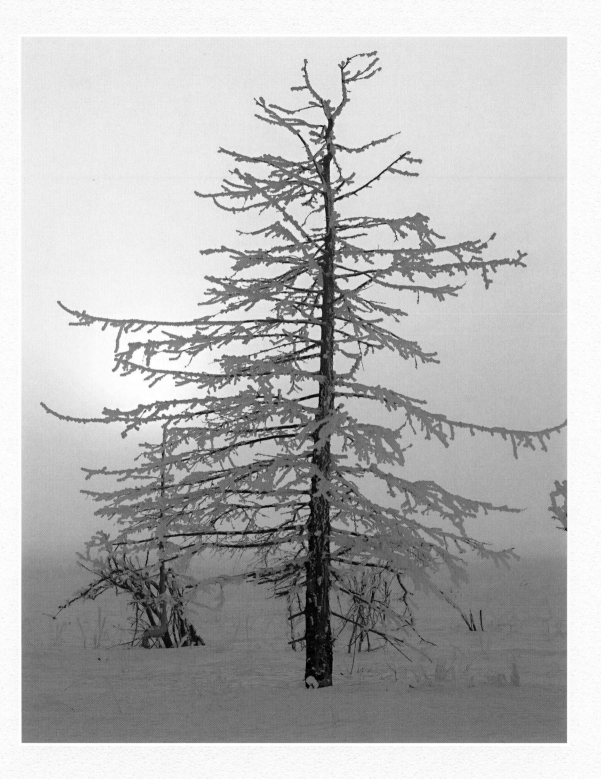

challenge

Challenge is the Iditarod's spine,
and history is its soul,
but love of dogs and mushing
will always be its heart.

Tony Dawson
ALASKA MAGAZINE

LEFT Rime ice covering white spruce tree,
Palmer Flats State Game Refuge
(Fred Hirschmann)

FACING PAGE Sled dog team, interior Alaska
(Jeff Schultz/Alaska Stock)

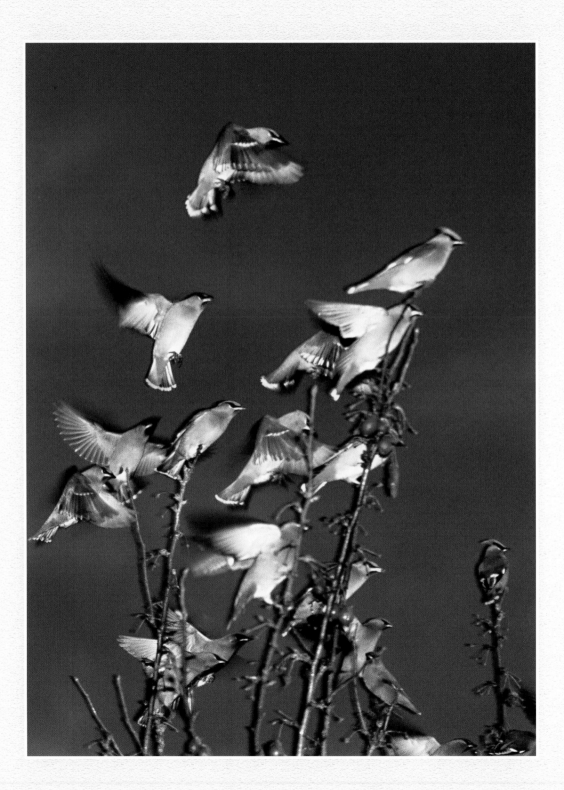

LEFT Bohemian waxwings, Anchorage
(Dorothy Keeler)

FACING PAGE High-bush cranberry,
Katmai National Park (Kim Heacox)

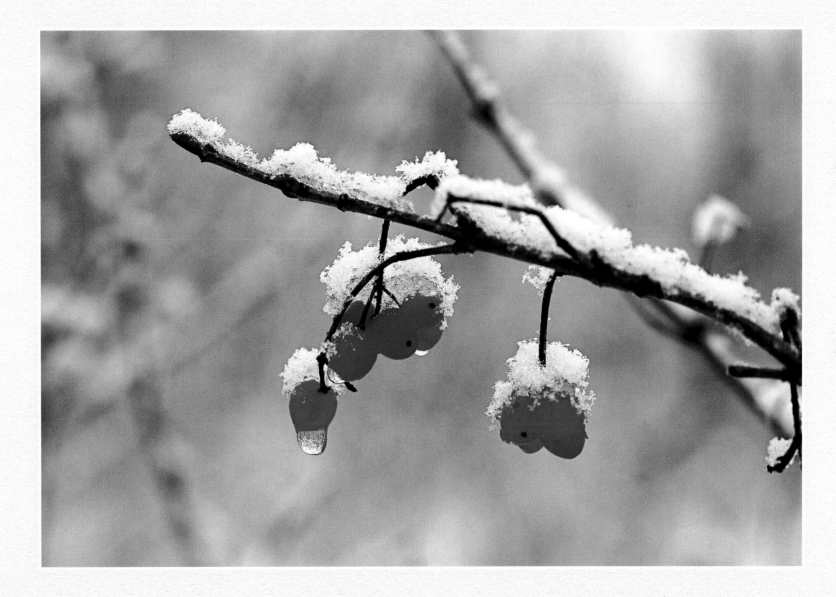

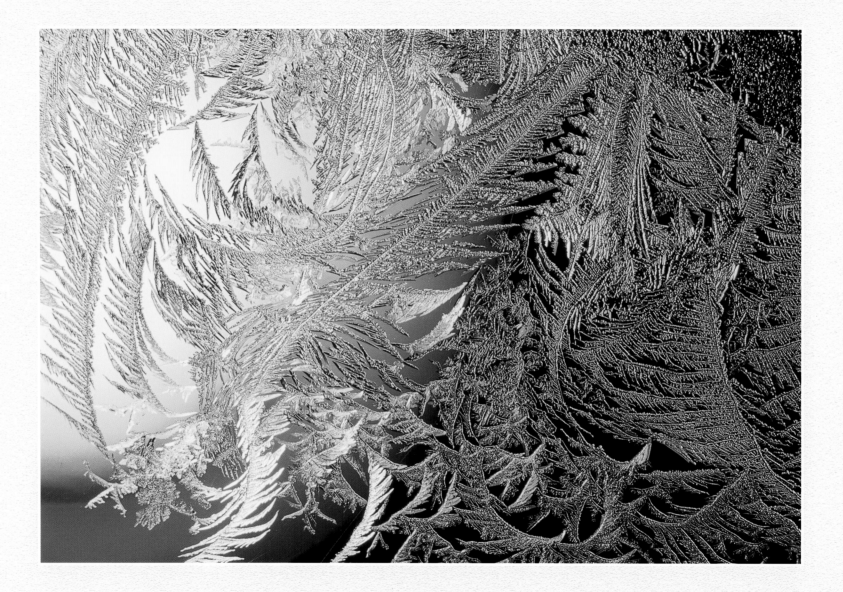

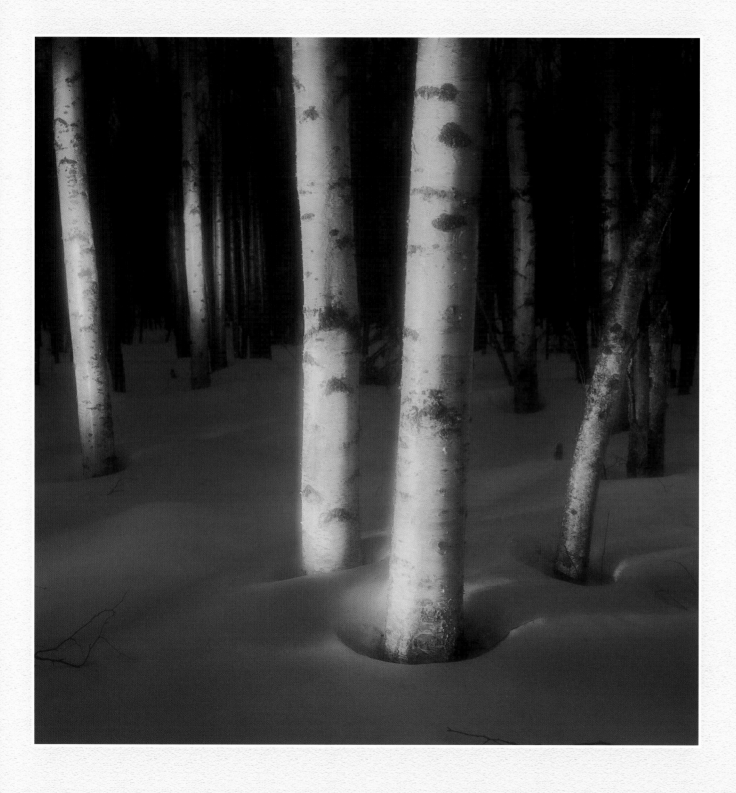

LEFT Birch trees at twilight,
Southcentral Alaska
(Kevin Smith/Alaska Stock)

FACING PAGE Frosted window
pane at sunset, Anchorage
(Vance Gese)

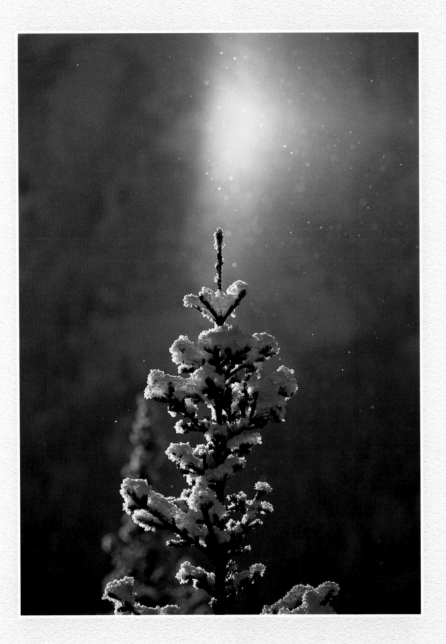

realities

Darkness, fire, frost and cold
are the internal environmental
realities of Alaska.

Robert Weeden
ALASKA: PROMISES TO KEEP

LEFT Sun dog above white
spruce tree, Interior Alaska
(Craig Brandt)

FACING PAGE Winter solstice,
sunrise to sunset in one hour
at -30°F (Craig Brandt)

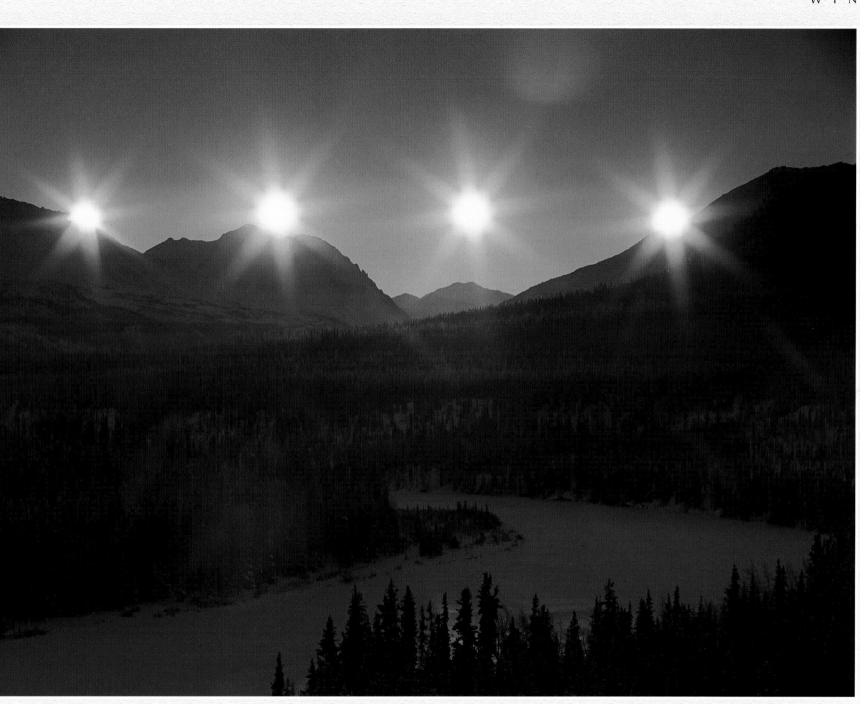

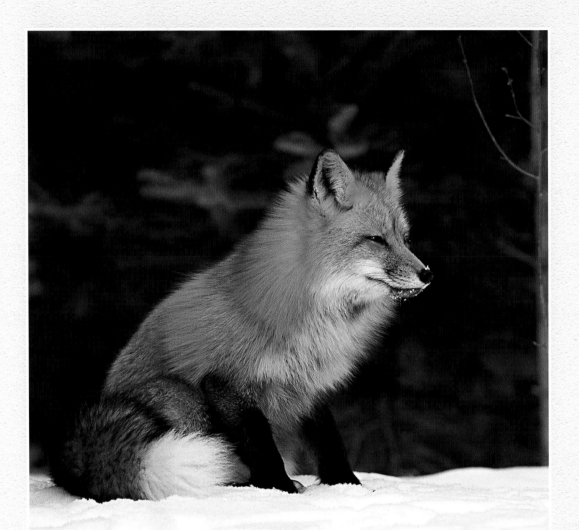

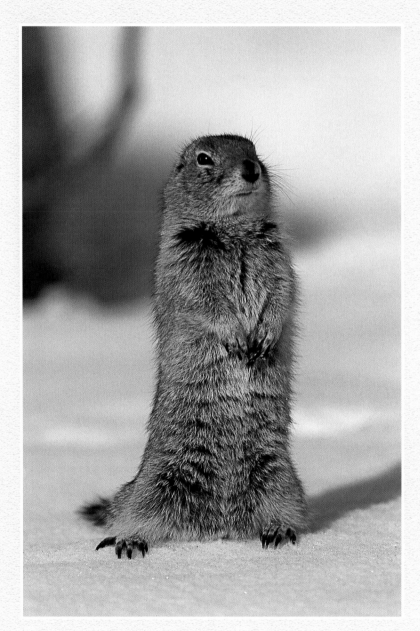

LEFT Red fox
(Tom Walker)

RIGHT Arctic ground squirrel
(Gary Lackie)

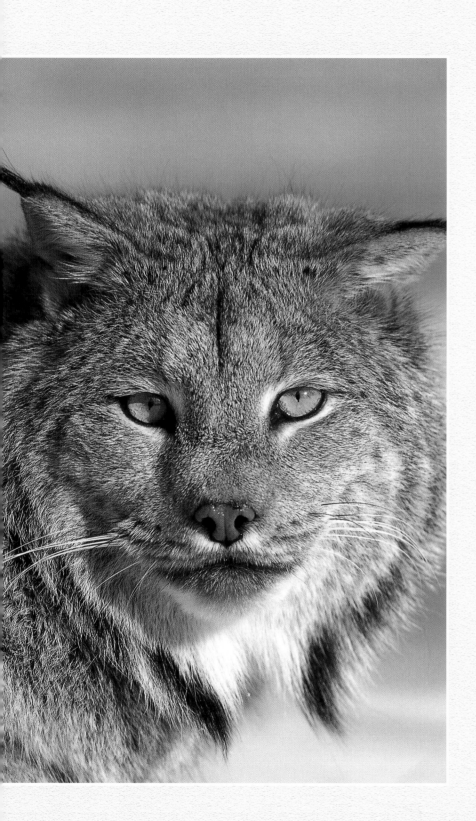

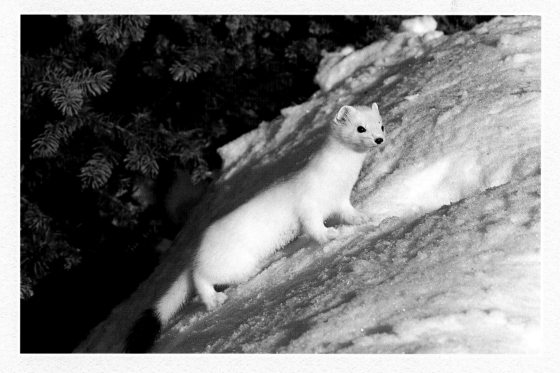

LEFT Lynx (Michael DeYoung)

RIGHT Weasel (Gary Lackie)

wonder

May your rivers flow without end...
where something strange and more
beautiful and more full of wonder than
your deepest dreams awaits for you...

Edward Abbey

RIGHT Little Susitna River, Talkeetna
Mountains (Randi Hirschmann)

FACING PAGE Frozen oxbow lakes, Yukon
River (Hugh Rose)

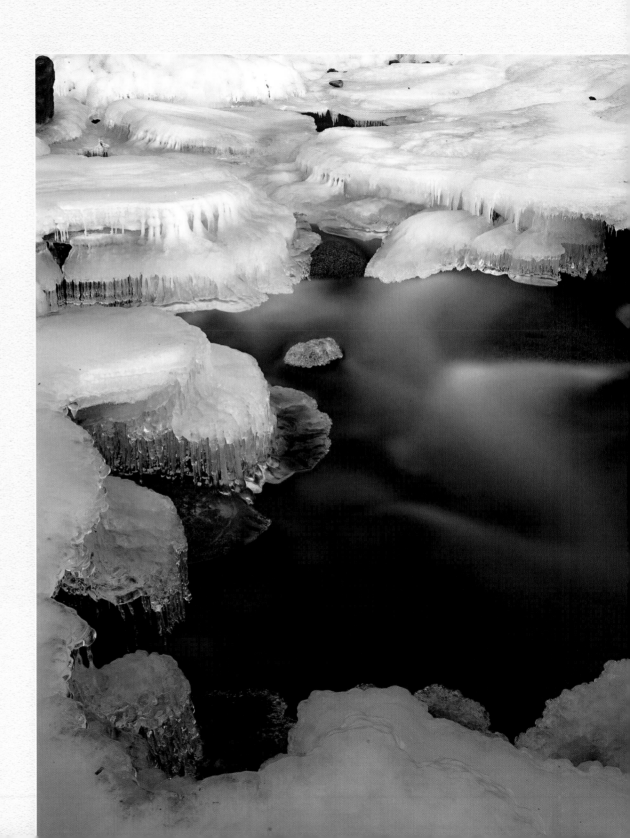

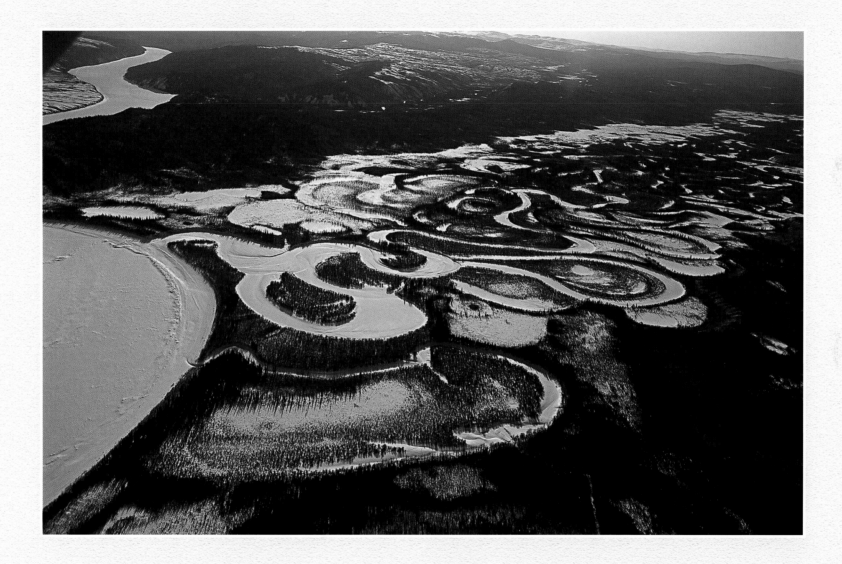

BELOW Mallard duck (Tom Walker)

RIGHT Bald eagle (Lon Lauber)

FACING PAGE Trumpeter swans in snowstorm,
Copper River Delta (Jo Overholt)

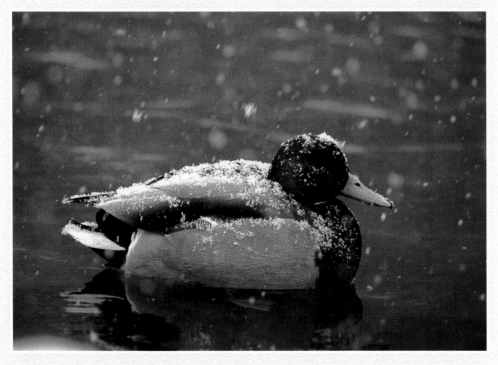

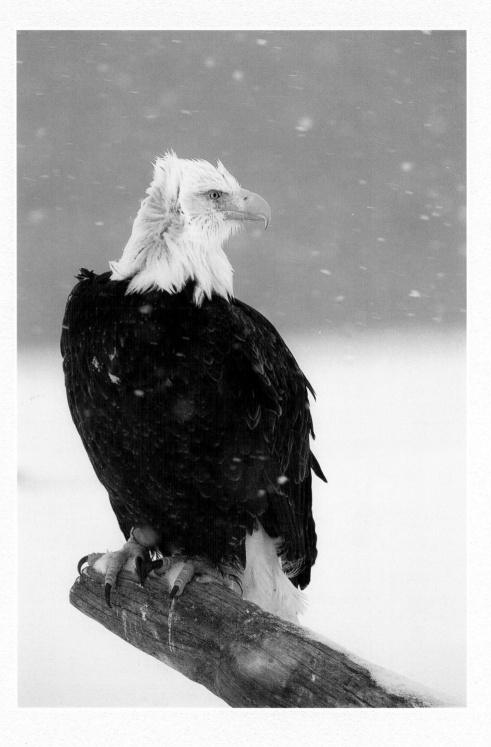

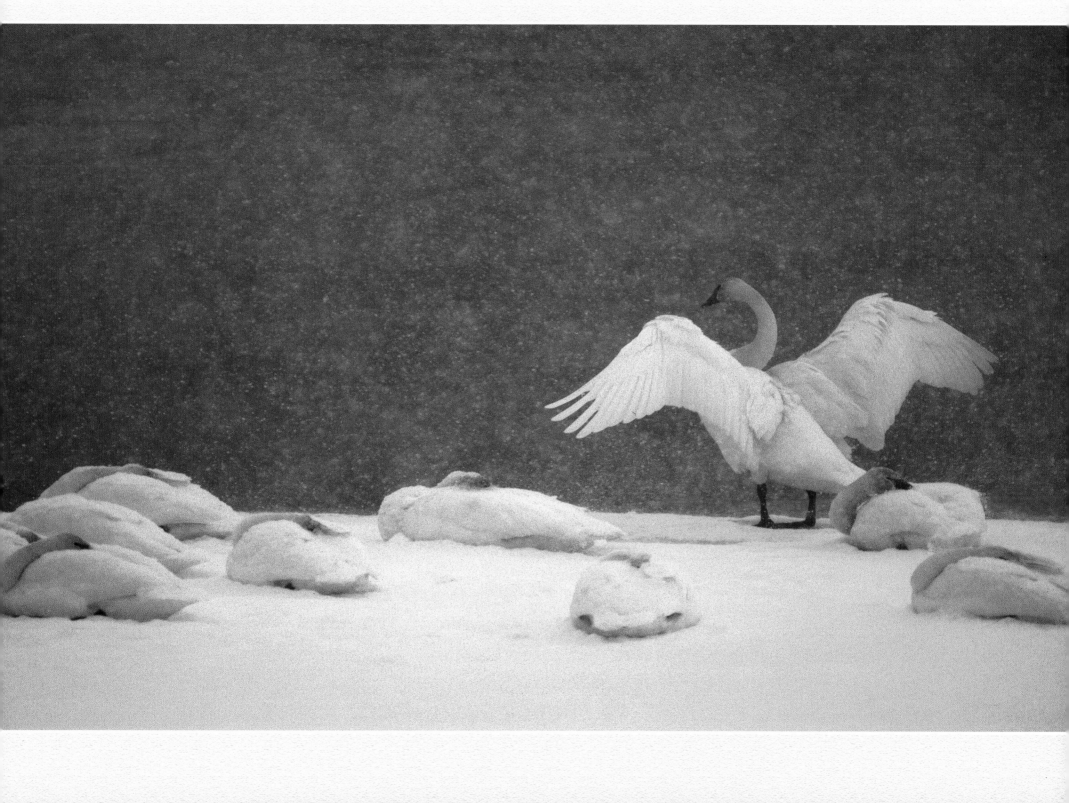

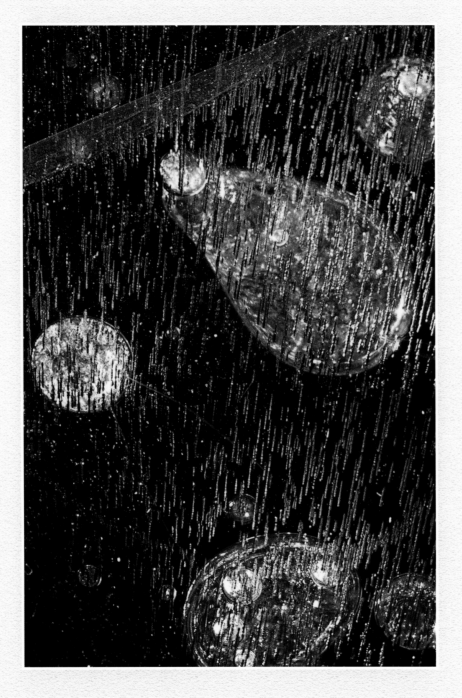

Air bubbles in Ice, Judd Lake
(Shelley Schneider)

beauty

Eventually (there) will be a time
when natural beauty
is more valuable than gold.

Susan Zwinger
STALKING THE ICE DRAGON

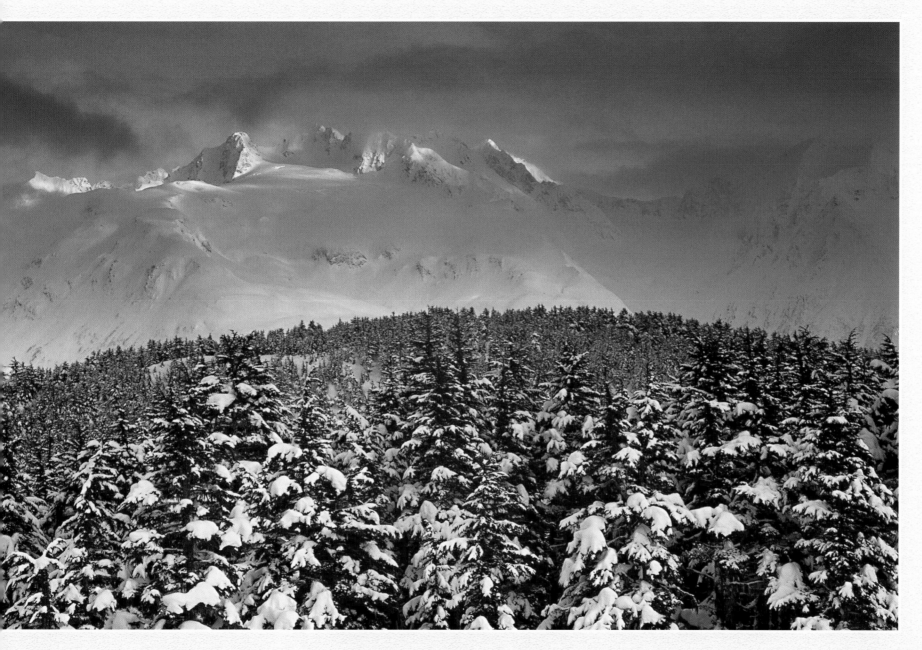

Snowy forest near Lost Lake, Chugach
National Forest (Ron Niebrugge)

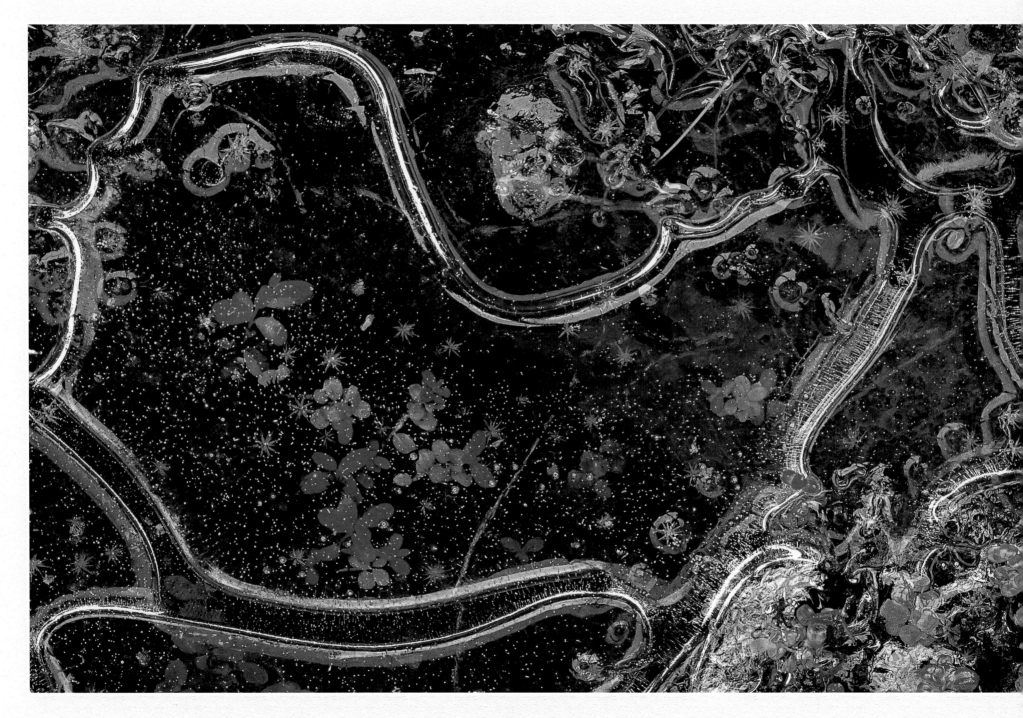

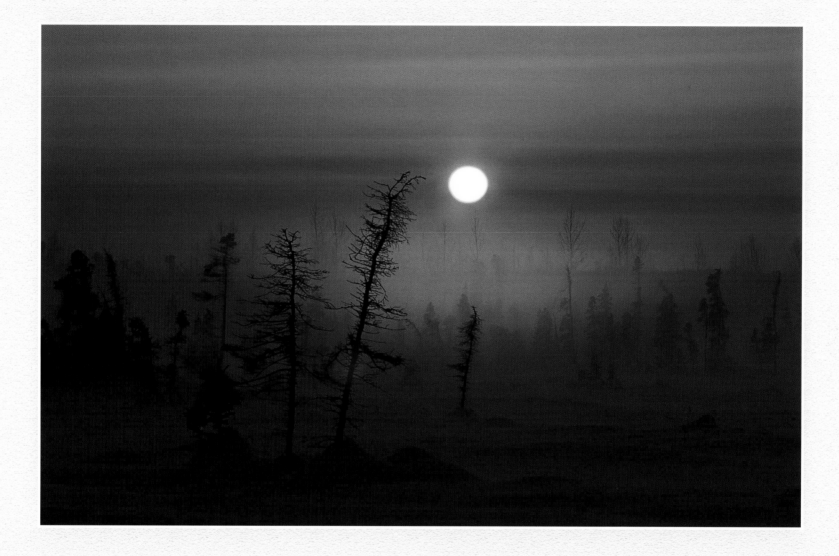

ABOVE Ice fog at sunset, Anchorage
(Calvin Hall)

FACING PAGE Blueberry plant frozen in ice,
Yukon Delta National Wildlife Refuge
(Vance Gese)

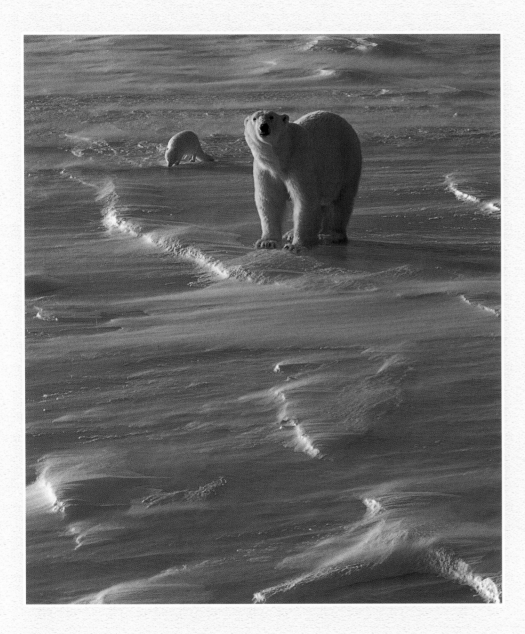

wildlife

The arctic would be barren and lonely
were it not for wildlife.

Raymond Dasman
A DIFFERENT KIND OF COUNTRY

LEFT Polar bear and fox
(Gary Schultz)

FACING PAGE Frozen minnow
and air bubbles, Judd Lake
(Shelley Schneider)

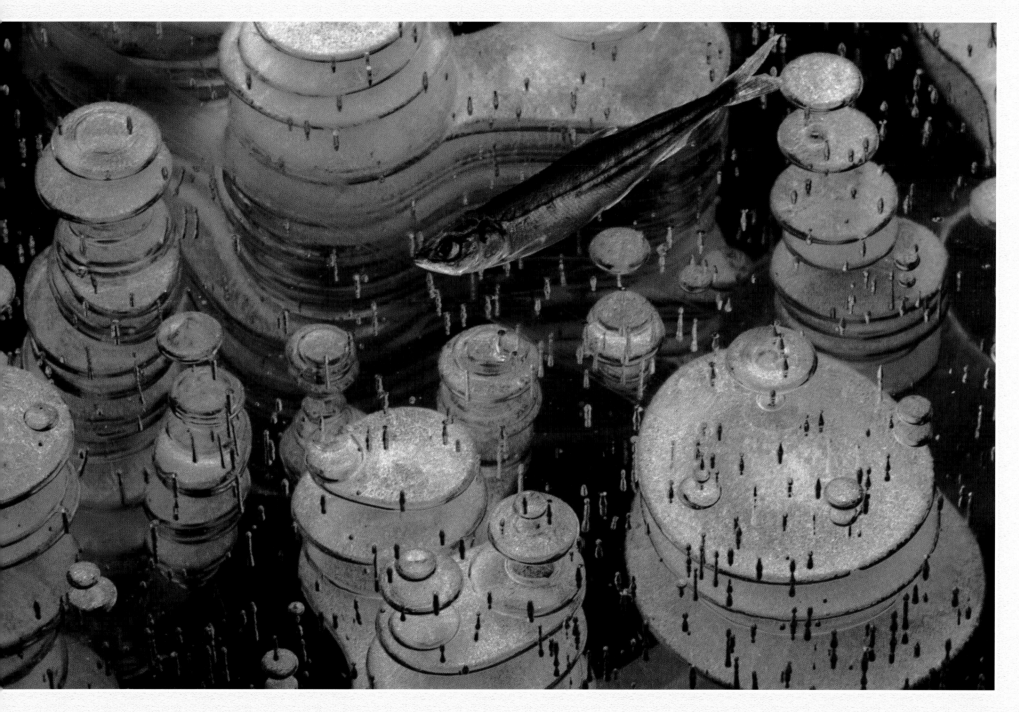

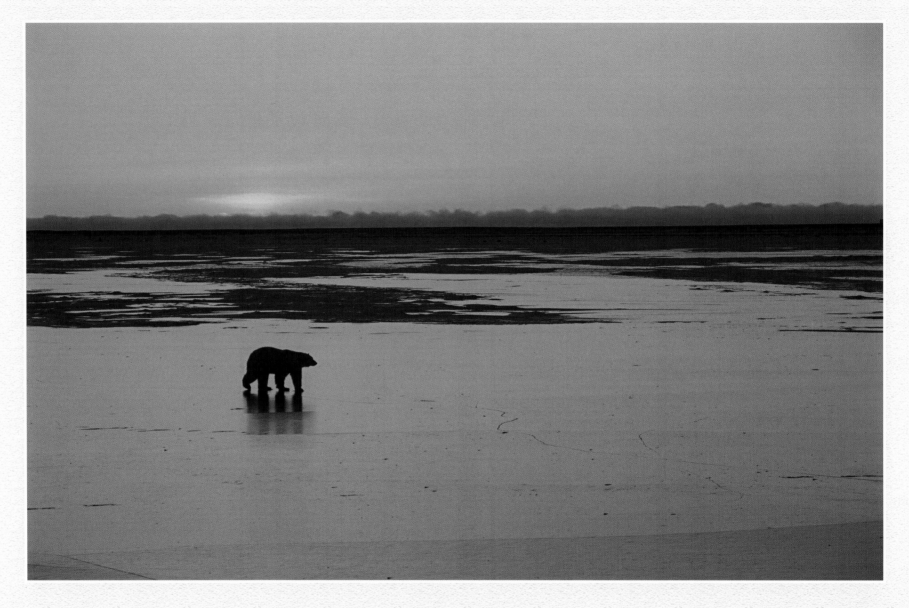

ABOVE Polar bear at sunset
(Jo Overholt)

RIGHT Polar bear sleeping
(Alissa Crandall)

FAR RIGHT Polar bear tracks
(Tom Soucek)

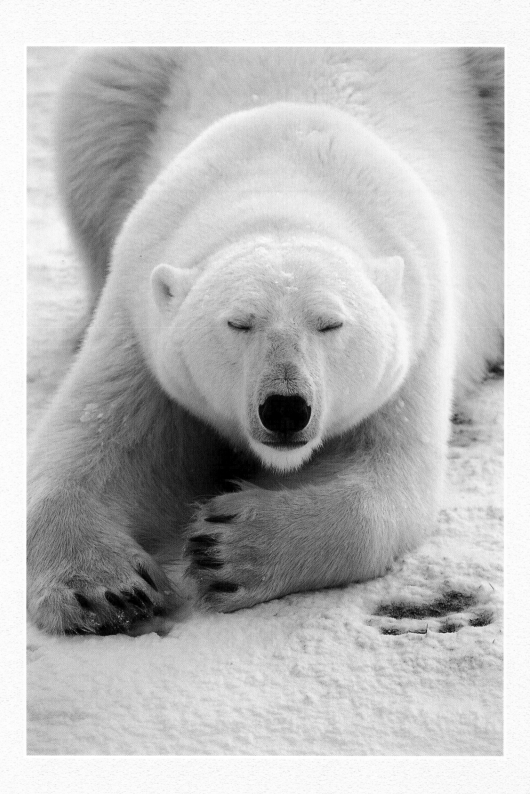

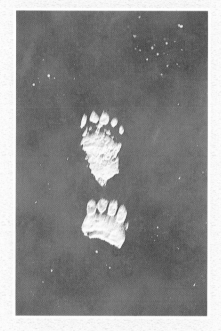

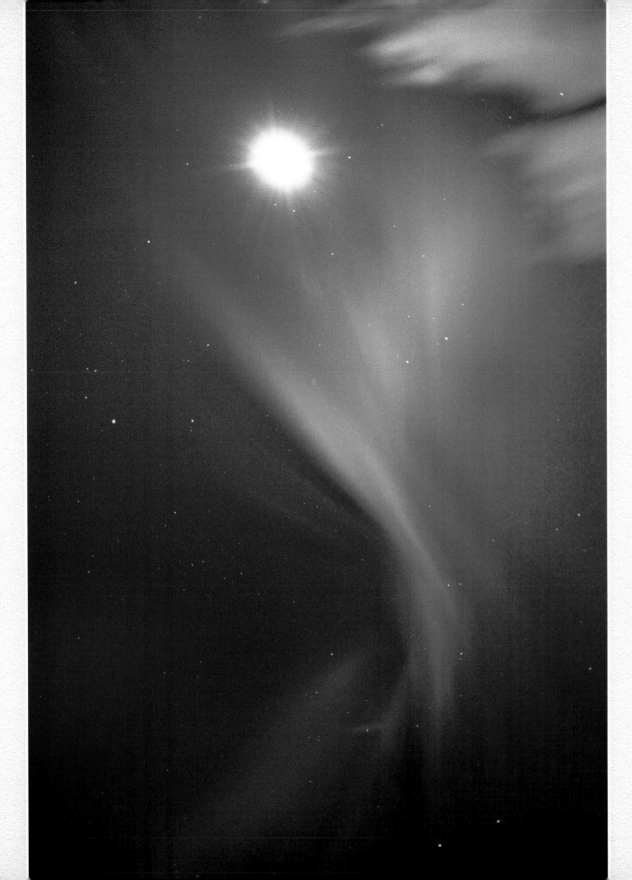

light

And everywhere there was clarity,
an exquisite purity of light.
Cast in its glow, the landscape
became surreal, dreamlike, timeless.

Nick Jans
LAST LIGHT BREAKING

LEFT Full moon and Aurora borealis,
Richardson Highway (Todd Salat)

FACING PAGE Aurora borealis over Kathleen
River, Haines Junction, Yukon Territory
(composite image by Michael DeYoung)

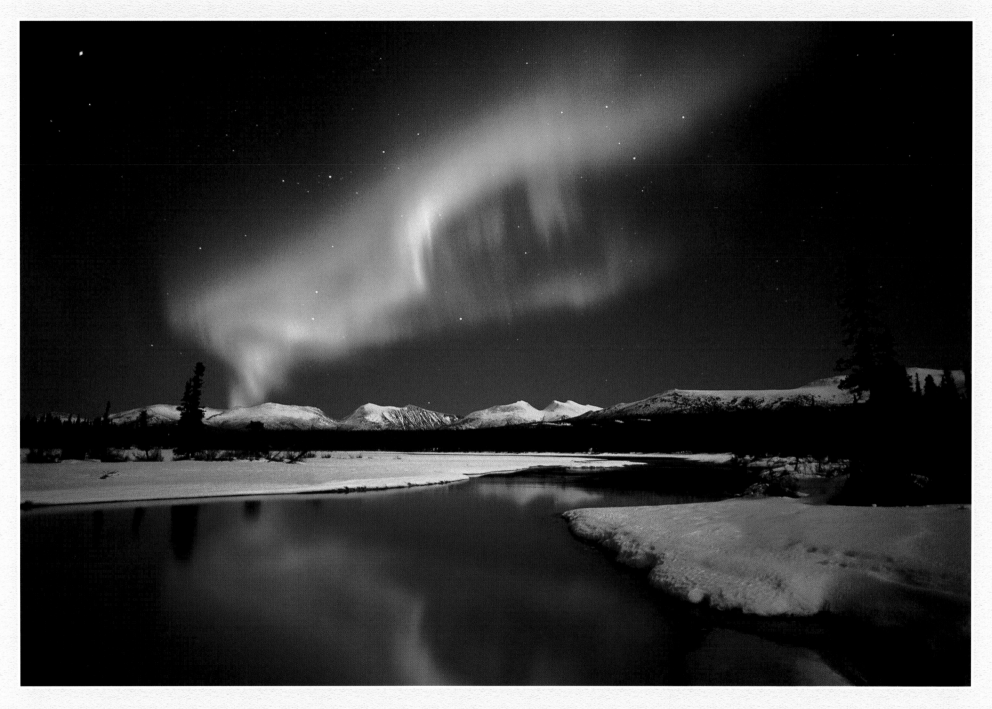

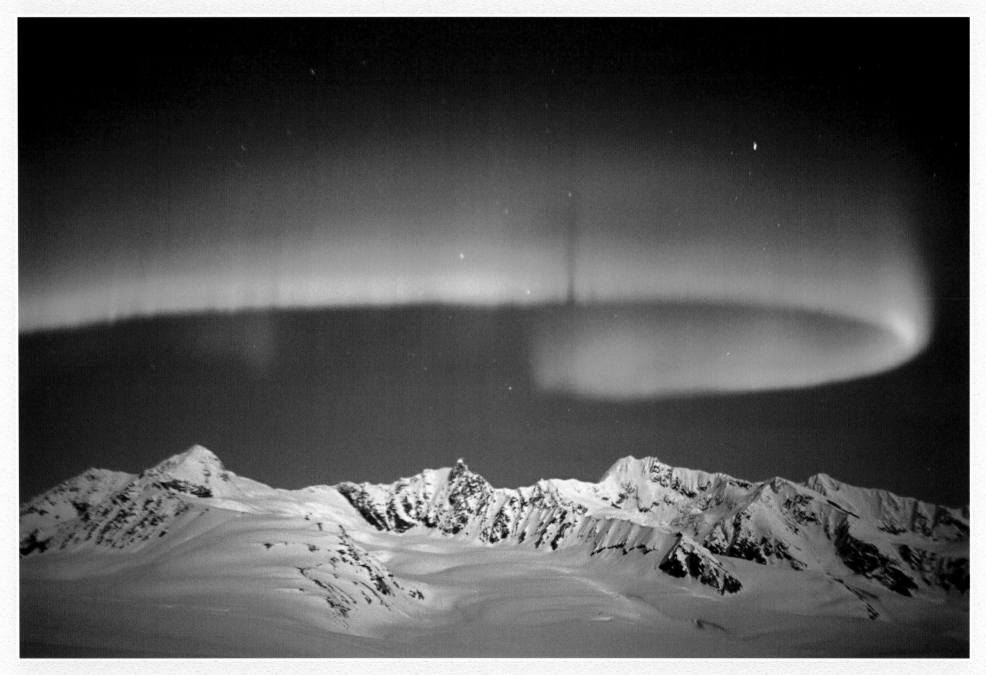

Aurora borealis and moonlit
Alaska Range (Patrick Endres)

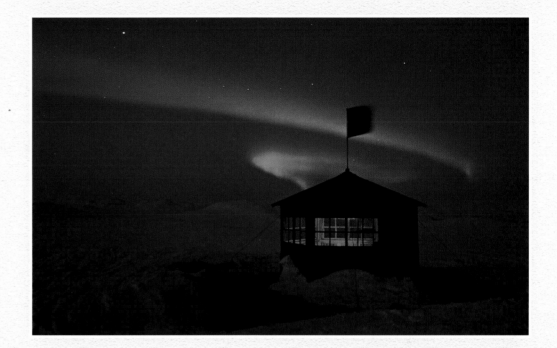

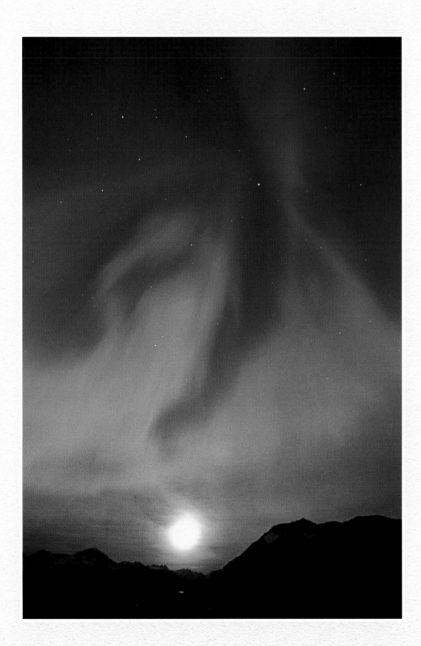

ABOVE Northern lights on Curry Ridge
(Calvin Hall)

LEFT Aurora borealis near Portage
(Calvin Hall)

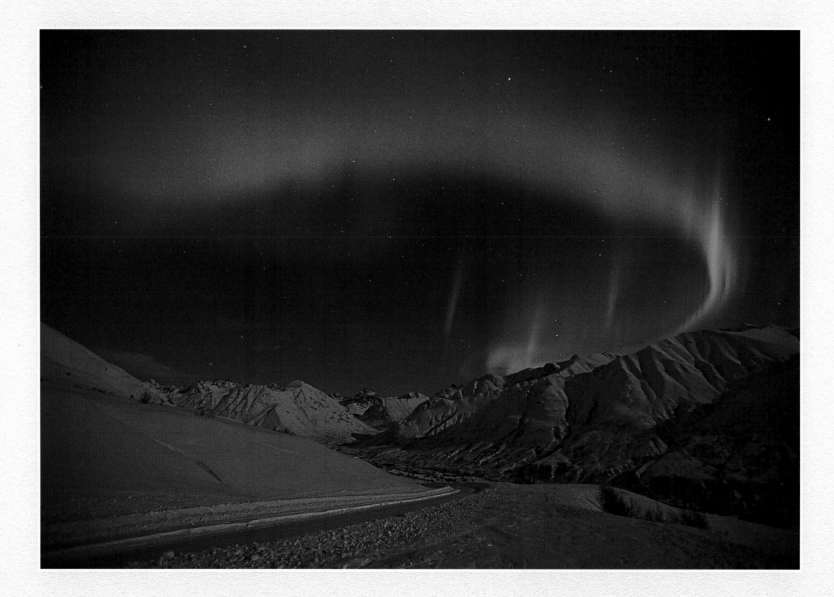

Aurora borealis, Hatcher Pass
(Calvin Hall)

 ## For further information

Einige nützliche Adressen, wo Sie
weitere Informationen erhalten
können.

さらに情報を得るために役にたつ住所。

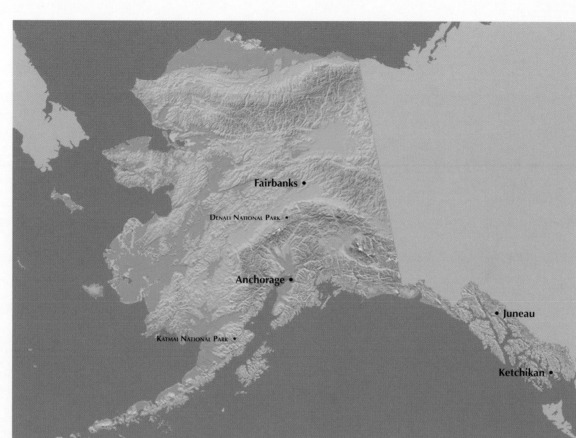

Recreation information and trip planning

Alaska Public Lands Information Center
605 W. Fourth Avenue, #105
Anchorage, AK 99510
1-907-271-2737
www.nps.gov/aplic/center

Alaska State Parks
Alaska Department of Natural Resources
www.dnr.state.ak.us/pic/recreate.htm

State of Alaska
www.state.ak.us

Alaska Division of Tourism
P. O. Box 110801
Juneau, AK 99811-0801

Alaska Wilderness Recreation and Tourism
 Association
2207 Spenard Road, #201
Anchorage, AK 99503
1-907-258-3171
www.alaskaecotourism.org

Alaska Travel Industry Association
P. O. Box 196710
Anchorage, AK 88519-6710
www.travelalaska.com
www.northtoalaska.com

Hunting and Fishing

Alaska Department of Fish and Game
P. O. Box 25526
Juneau, AK 99802-5526
www.state.ak.us/local/akpages/FISH.GAME/

Rail travel

Alaska Railroad Corporation
P. O. Box 107500
Anchorage, AK 99510
1-907-265-2494
1-800-544-0552
www.alaskarailroad.com

White Pass and Yukon Route Railroad
P. O. Box 435
Skagway, AK 99840
1-907-983-2217
1-800-343-7373
www.whitepassrailroad.com

Ferry boats

Alaska Marine Highway
1591 Glacier Avenue
Juneau, AK 99801
1-907-465-3941
1-800-642-0066 (US/Canada)
www.dot.state.ak.us.amhshome.html

Anchorage Convention and Visitors Bureau
524 W. Fourth Avenue
Anchorage, AK 99501-2212
1-907-274-3531
1-800-478-1255
www.anchorage.net

Fairbanks Convention and Visitors Bureau
550 First Avenue
Fairbanks, AK 99701-4790
1-907-456-5774
1-800-327-5774
www.explorefairbanks.com

Juneau Visitor Information Center
134 Third Street
Juneau, AK 99801
1-907-586-2201
1-888-581-2201
www.juneau.com

Southeast Alaska Tourism Council
P. O. Box 20710
Juneau, AK 998021-0710
1-907-586-4777

Ice sculture at World Ice Art
Championships, Fairbanks
(Patrick Endres)